BRENTWOOD & AROUND

THROUGH TIME

Kate J. Cole

AMBERLEY

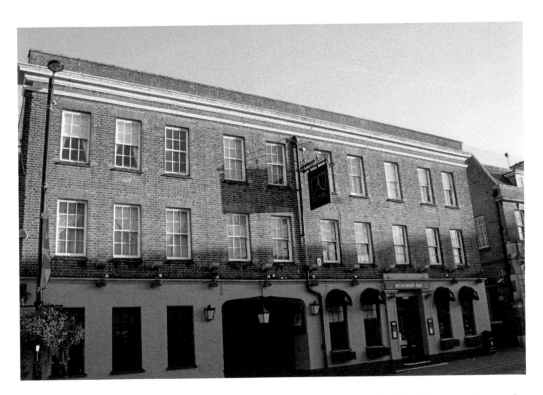

The White Hart, once the hostelry where Richard II rested his weary head in the 1390s, is now the location of a hit reality television series. Step inside my book to see how this ancient town once looked and how times (and historic buildings' uses) have changed over the centuries.

First published 2016

Amberley Publishing
The Hill, Stroud, Gloucestershire, GL5 4EP
www.amberley-books.com

Copyright © Kate J. Cole, 2016

The right of Kate J. Cole to be identified as the
Author of this work has been asserted in accordance with
the Copyrights, Designs and Patents Act 1988.

ISBN 978 1 4456 4835 4 (print)
ISBN 978 1 4456 4836 1 (ebook)

British Library Cataloguing in Publication Data.
A catalogue record for this book is available from the
British Library.

Origination by Amberley Publishing.
Printed in Great Britain.

Contents

	Introduction	4
CHAPTER 1	Brentwood	5
CHAPTER 2	Warley	44
CHAPTER 3	Shenfield	59
CHAPTER 4	Hutton	75
	Bibliography	91
	Acknowledgements	92

Introduction

I have written several books in Amberley Publishing's excellent *Through Time* series and I have thoroughly enjoyed personally researching, photographing and writing each book. However, this book, which includes the towns of Brentwood, Warley, Shenfield and Hutton, is very dear to my heart. When I moved to Essex in 1989 (originally temporarily to Billericay), I looked at Hutton as the place to make my first permanent home within the county. So it was to houses on Woodlands Avenue and Hutton Drive (both in Hutton) where I first brought home my two daughters 'from the hospital' in 1990 and 1994. I left the area twenty years ago. When I returned to photograph the pictures within this book, I was coming back to a place where I had many fond memories of my daughters' earliest years. The streets I walked through to take my photographs for this book were so familiar to me and the years slipped away as if I had never left (in those days pushing a pram, but now carrying a camera).

Although I have been away a mere twenty years, while researching this book I saw some incredible changes to the area. For example: the dark, forbidding (and quite frankly, scary) Victorian Warley Hospital, where I once frequently visited a family member is now luxury million-pound apartments set in picturesque landscaped grounds; High Wood Hospital is now another luxury development of expensive houses. Other changes have happened, such as the near overrunning of Brentwood town centre by cult celebrity television programme, *The Only Way is Essex*. The changes to this area of Essex in just the last twenty years are quite staggering. While I was photographing for this book, I got an incredible sense that I was capturing a snapshot in time; how the area looked in 2016: Before it all changes again – with new buildings, new housing developments and even new rail services.

However, my book is not just about the changes that I have personally witnessed, but also the changes that have happened over the last hundred or so years. Many of the vintage postcards depicting street scenes of the area's past within this book have already been reproduced in other excellent local history books. So it was a daunting task to write another local history book that uses many of the same images. Nevertheless, by using modern-day photographs to compare the past with the present, my book dramatically differs from those that went before. But to those authors whose books appeared before mine, I owe a debt of gratitude; and I hope that in time my book will also become part of the literature regarding the history of the area.

This book is not so much the history of these four places, but rather it graphically traces some of the changes that have taken place in this part of Essex over the last hundred or so years. I hope you enjoy looking at Brentwood's, Warley's, Shenfield's and Hutton's individual journeys through time.

Kate Cole
Maldon – Autumn 2016
www.essexvoicespast.com

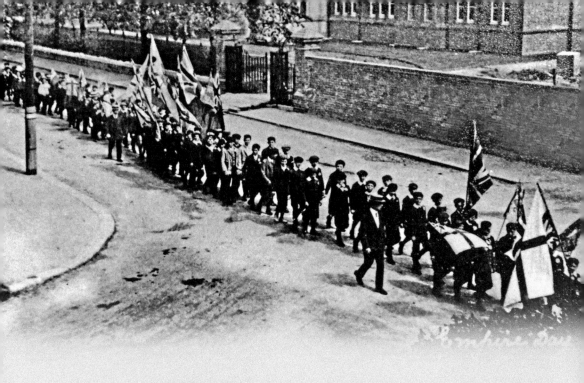

CHAPTER 1

Brentwood

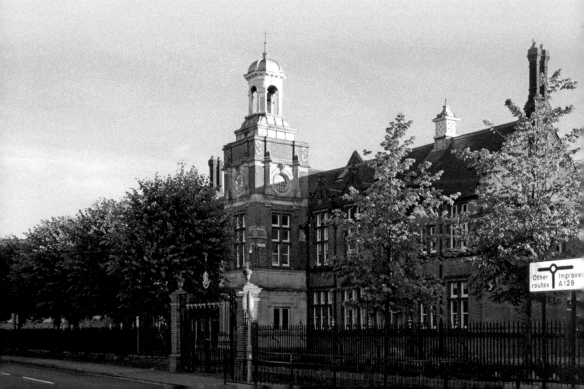

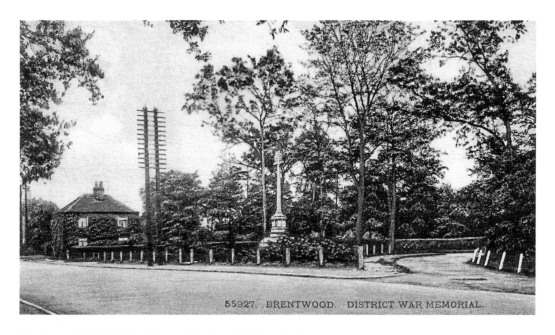

55927. BRENTWOOD. DISTRICT WAR MEMORIAL.

Brentwood District War Memorial, Shenfield Road, after 1921

The district's War Memorial was initially proposed to be built in the town centre. A spot near Wilson's Corner (roughly where the modern-day double-roundabout is located) was identified by the war memorial's committee as a suitable location. However, the initial site was rejected by the council as being too dangerous after a dummy structure was placed there. After much controversy, the War Memorial to the dead service personnel of Brentwood, Warley, Shenfield, South Weald and other of the district's smaller villages, was built outside the town's centre. It was dedicated in October 1921, in front of 6,000 people. The image above shows the original memorial cross, which commemorates the fallen of the First World War. After the Second World War, the Memorial Wall (seen on the bottom photograph) was built in memory of the locals who lost their lives in the war. The memorial did not fare well in the weather's elements; by the start of the twenty-first century, it was in much need of repair and repointing. The memorial was restored and renovated in 2010 at a cost of approximately £50,000.

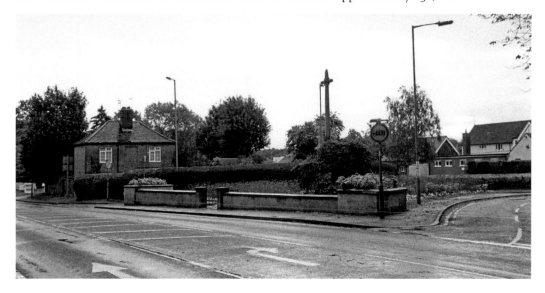

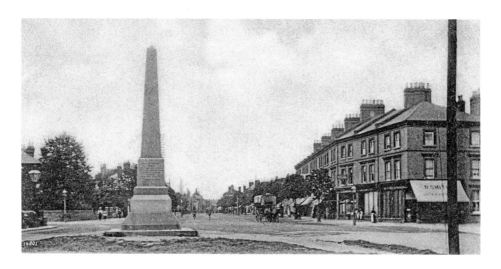

Shenfield Road (facing High Street), early 1900s

The monument to the Marian martyr William Hunter (d. 1555) is on the approach to Brentwood from Shenfield. The monument was built in 1861 at a cost of £350 (raised by public subscription) and was erected on land then owned by Dowager Lady Cowper of Shenfield. In 1553, Mary I became the queen of England. At a time of great religious turbulence within England, the queen attempted to revert the country to the pre-Reformation religion of Catholicism. Many people, including young artisans within Essex, rejected this return and wanted to continue to practise Protestantism. William Hunter was one such artisan. He was a nineteen-year-old London silk-weaver who refused to attend church in London so returned to live at his father's house in Brentwood. In Brentwood, he refused to accept the Catholic doctrine of transubstantiation and, as a consequence, was brought first before Sir Antony Browne (at that time, the local justice), and then the Bishop of London, Edmund Bonner. He was burnt at the state in Brentwood in 1555. The inset is a plaque on the monument. It was damaged by the fire at Wilson's Corner in 1909 and was restored the following year.

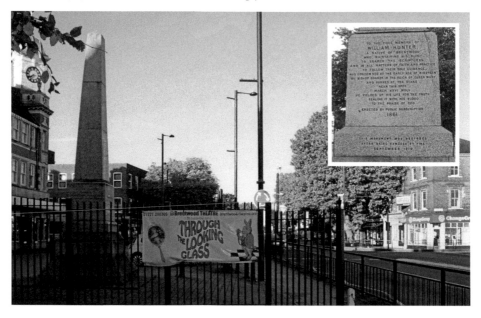

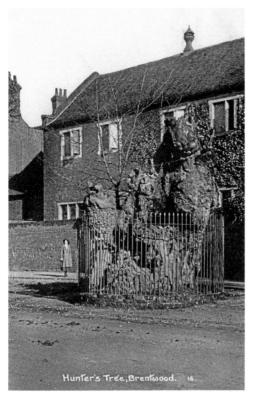

Hunter's Tree, Brentwood. 16.

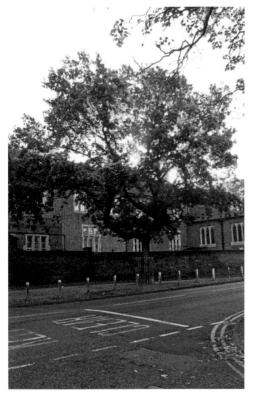

Martyr's Elm, Ingrave Road, postmarked 1912

Hunter refused to renounce his stance against Catholicism, and, as a result, was burnt at the stake as a heretic in Ingrave Road on 27 March 1555. An elm tree was grown at the same location as his martyrdom shortly afterwards. The remains of the ancient elm tree stayed at the site for nearly 400 years, until it was removed in 1952. In 1936, a new oak tree was planted nearby to mark the coronation of George VI. The top photograph is from around 1912 and shows the original elm tree. The bottom left photograph shows the 1936 oak tree outside one of the oldest parts of Brentwood School. The image below right shows the plaque on the elm tree commemorating the coronation of George VI.

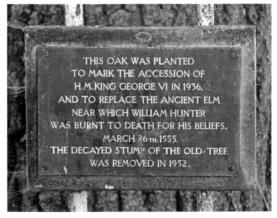

THIS OAK WAS PLANTED
TO MARK THE ACCESSION OF
H.M.KING GEORGE VI IN 1936,
AND TO REPLACE THE ANCIENT ELM
NEAR WHICH WILLIAM HUNTER
WAS BURNT TO DEATH FOR HIS BELIEFS,
MARCH 26th 1555.
THE DECAYED STUMP OF THE OLD TREE
WAS REMOVED IN 1952.

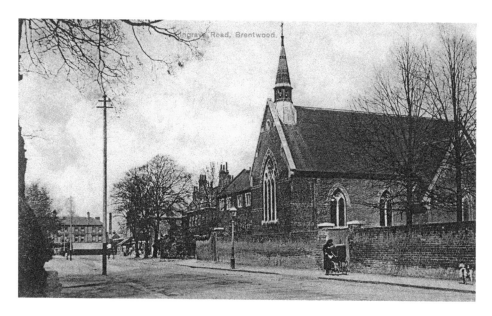

Brentwood School, Ingrave Road, postmarked 1907

Brentwood School was founded as a boys' grammar school in the late 1550s by Sir Antony Browne (1509–67). During its first two centuries, the school only had day pupils, but admitted boarders in 1765. Despite its successful start, its fortunes steadily declined; by 1806 there were only twelve pupils. However, under an inspirational headship in the 1850s, the school had a revival and its prosperity flourished. In 1974, it admitted girls into the sixth form for the first time. Girls from the age of eleven upwards were permitted in the secondary school from 1988. The building shown in the pictures on this page is the school's chapel, which was built in 1868 and amended in the 1920s. The photographs on the opening page of this chapter show the school's main building (built in 1910). A large parade of children from all the town's schools and scout detachments marched through the town on their way to Shenfield Common, passing Brentwood School, on Empire Day in May 1912.

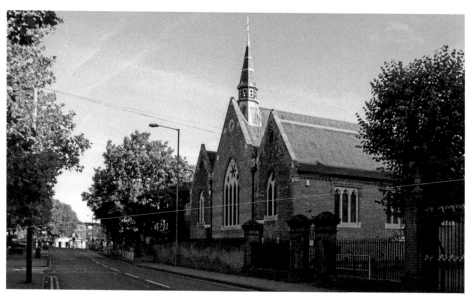

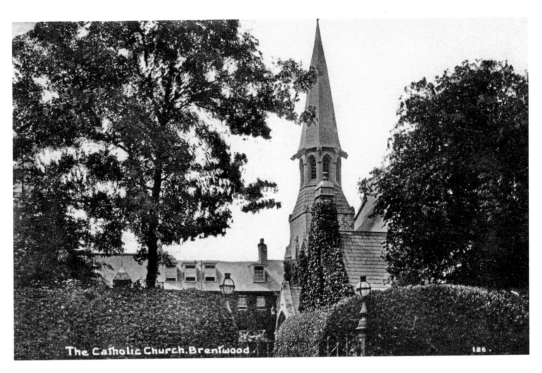

Brentwood Catholic Church of Saint Mary and Saint Helen, c. 1910s

Brentwood's Catholic Cathedral started as the Church of St Helen's and was built in 1836–37 by the architect Henry Flower. The original 1830s church was used as a school and parish hall during the 1860s. A new church was built in 1861. It was in the Gothic style and designed by G. R. Blount. Pevenser, writing in the 1950s, stated that this church was 'of that assertive ugliness which is characteristic of much church work of the sixties [1860s]'. Between 1989 and 1991 the church was totally rebuilt and redesigned by the architect Quinlan Terry in the classical style. On 31 May 1991, Cardinal Basil Hume dedicated the new Brentwood Cathedral.

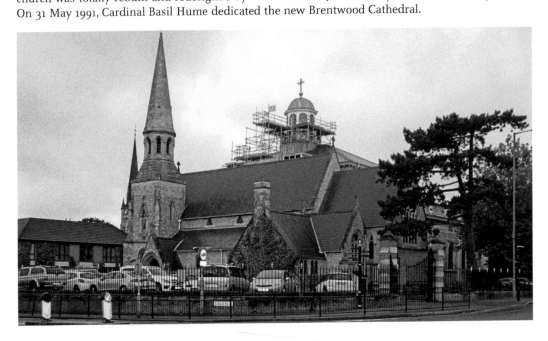

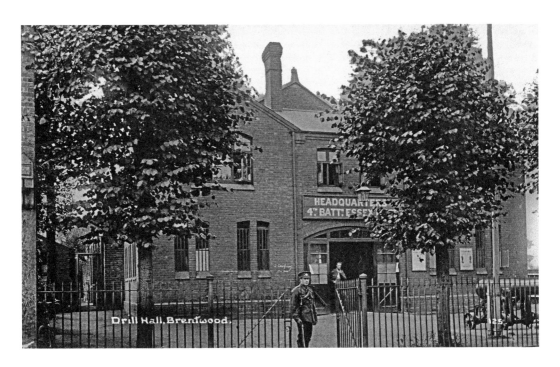

Drill Hall, Ongar Road, postmarked April 1916

The Drill Hall in Ongar Road was built in 1886 at the cost of £2,000. It was the headquarters of the 4th Territorial Battalion of the Essex Regiment while other regiments, clubs and societies (such as Brentwood's Operatic Society) also used the building. The message on the back of the above postcard, which was sent in 1916, states: '1190 Cpt Morrison, 2/1 Kent Cyclists. Dear Harry, I'm here for 3 weeks. Have just arrived. If possible I will run down but it's hard to get passes.' In the 1970s, the Drill Hall became a warehouse for the shop Eades. It was demolished towards the end of the twentieth century to make way for the North Service Road, now renamed William Hunter Way (in remembrance of the town's sixteenth-century martyr).

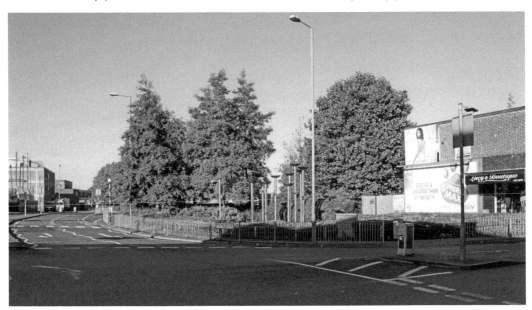

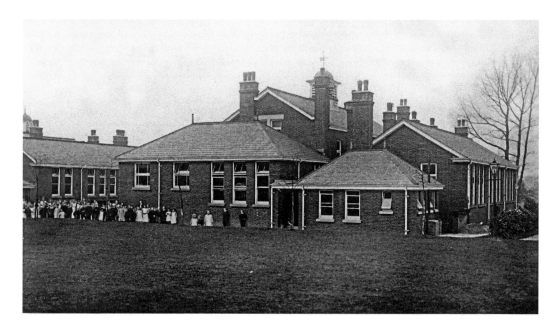

High Wood Hospital and Schools, postmarked 1908

High Wood Hospital was opened in 1904, built on a 20-acre site in the design of a 'cottage home' It was for children with specific contagious diseases. The hospital had groups of cottage wards, two schoolrooms (one junior, one senior) and an administrative block. During the First World War, the War Office took over the hospital, but its function returned to that of children's hospital a year after the end of the war. During the Second World War, an Emergency Medical Service (EMS) hospital (an annexe to the London Hospital) was built within the site. The children's hospital closed in the 1950s. From the 1960s its buildings were used as outpatient clinics and geriatric care, while the former EMS building became Little High Wood, a facility for children with complex additional needs. By the 2000s, the clinics and hospitals had vacated the buildings and High Wood was derelict for several years. In the 2010s, the site became a conservation area, developers moved in and, by 2013, the former children's hospital became a des-res development known as Burntwood Square. The photographs on this page show the senior school of High Wood Hospital, which is now a block of luxury one- and two-bedroomed houses/apartments.

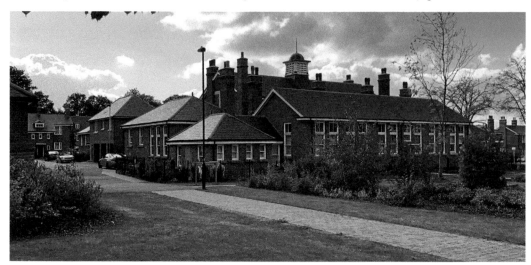

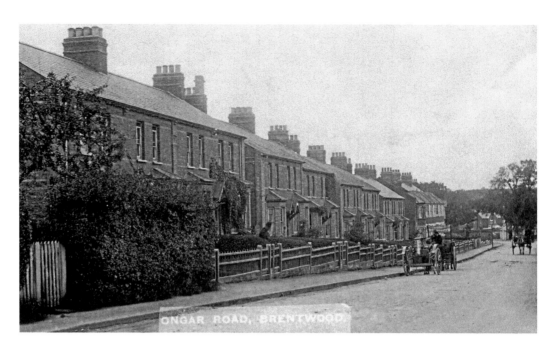

Ongar Road (facing away from town), postmarked 1913

Today, the Ongar Road is a long road with a curious mix of industrial and shop units, alongside residential double-fronted villas and workers' terraces dating from the late Victorian period. The Victorian terrace in the above photo is located just past the roundabout for Geary Drive. At the beginning of the twentieth century, each of these houses had tidy front gardens, which have now been replaced by much needed off-road parking for the residents. In the Edwardian scene, a dray for the Old Hornchurch Brewery is driving up the road towards Brentwood's town centre. Its destination is perhaps one of Ongar Road's Victorian public houses.

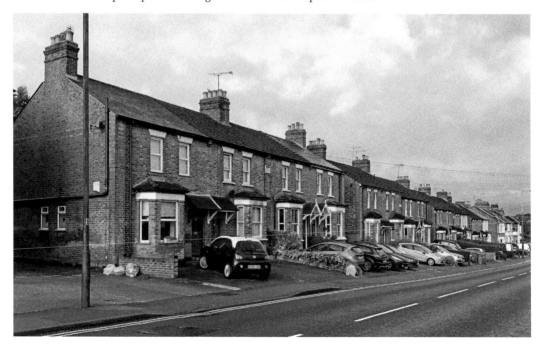

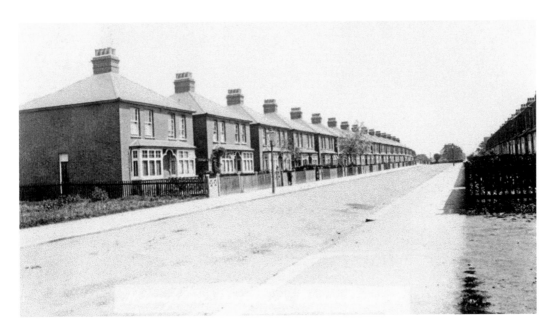

Kimpton Avenue, postmarked 1913

Built on land owned by a Brentwood brewery family, Kimpton Avenue is another road showing the town's urbanisation during the end of the nineteenth century and the beginning of the twentieth century. The architecture of these semi-detached two-bedroom villas is interesting as the entrance to each pair of houses is on the sides of the villas. When they were first built, each house cost in the low hundreds of pounds; today they fetch sums in the region of half a million pounds.

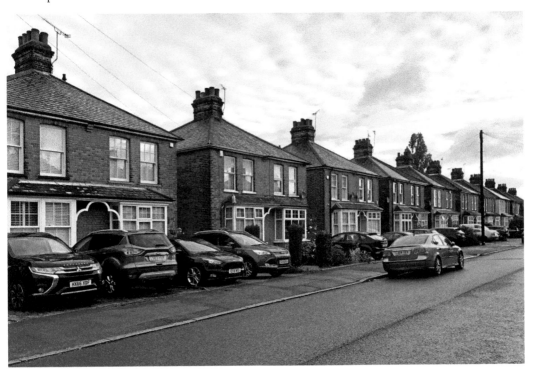

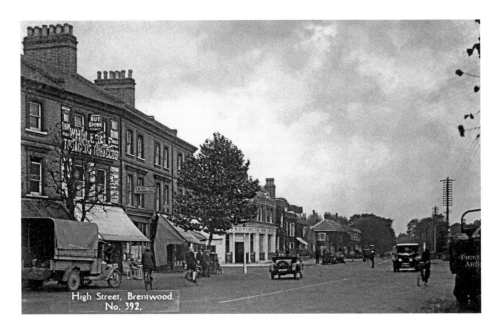

High Street, Brentwood.
No. 392.

High Street (facing east), 1920s/1930s

The National and Provincial Building in the centre of the above street scene demonstrates that the view was photographed sometime after 1928, when the building was converted from a family home into a bank. The building continued for some decades as a bank or building society but part of the building is now a brightly painted clothes shop, with a firm of solicitors occupying the office space above it. Next to it is the building known as the Old House (inset); built in the 1500s but first documented in 1748, it had many modifications made during the following centuries. At one point in the twentieth century, it was part of Brentwood School, then became an arts and community centre, but was empty for some years in the 2010s. At the time of writing the fate of the Old House is still undecided, with some developers wanting to turn the empty building into luxury apartments, while others want its function to remain for the benefit to the community.

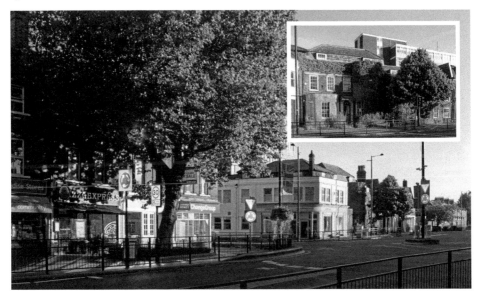

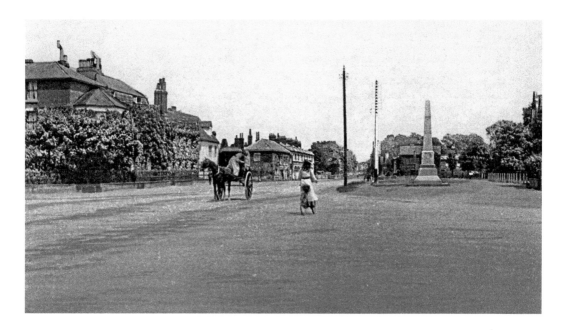

Shenfield Road (facing east), early 1900s

The building on the left of the Edwardian photograph was a family home at the time of the top photograph, but was converted into a bank in the late 1920s. The top scene shows a sleepy, empty road with a young girl leisurely cycling next to the horse and cart. This peaceful scene is no longer the case. It has become a busy intersection for traffic travelling in and out of the town centre, which can only be photographed early on a Sunday morning. One significant change to this part of Brentwood is the two mini-roundabouts at Wilson's Corner, directing traffic into and out of Brentwood's main shopping streets. They are notorious for being exceptionally difficult to navigate by uninitiated motorists.

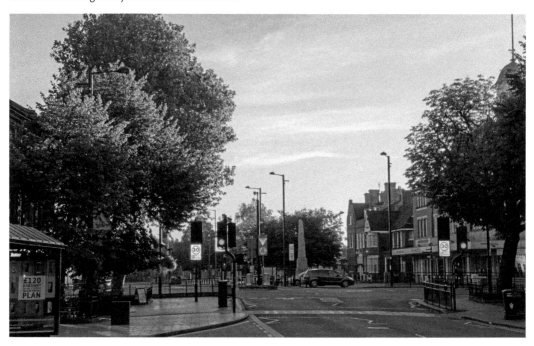

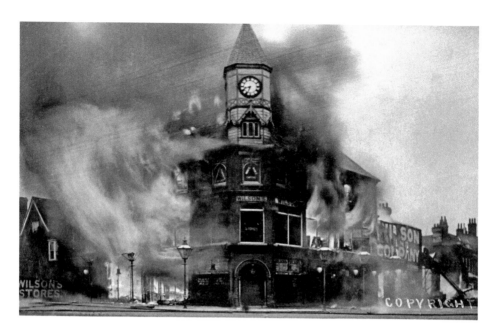

Fire at Wilson's Stores, 1909

The shop shown in the Edwardian photograph was built in the 1880s and housed Wilson's Great Eastern Stores (often abbreviated to Wilson's Stores). In 1909, there was a catastrophic fire that destroyed most of the buildings and Wilson's premises had to be rebuilt. In the later part of the twentieth century, the building housed the furniture store Coopers, although the name of the previous occupiers lived on through the name of the area, Wilson's Corner. Today, the furniture has disappeared from the site and one of its former showrooms is used as a beauty salon by a star of the reality television programme, *The Only Way is Essex*.

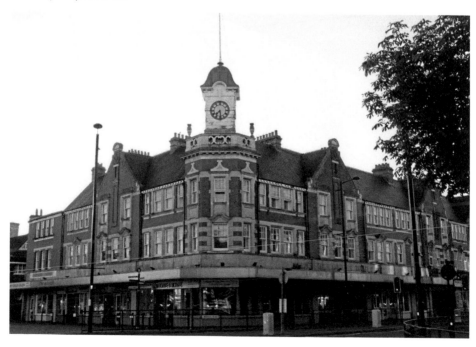

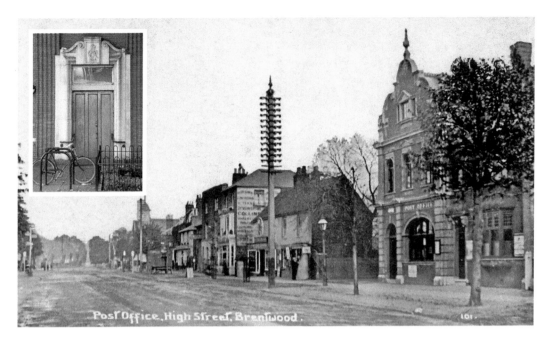

Post Office and High Street (facing east), postmarked 1919

The building on the right side of the top scene was Brentwood's post office, built in the 1890s but replaced by the present-day building in the late 1930s. There has been a post office in Brentwood since the early 1600s. Prior to building the town's 1890s post office, Brentwood's Victorian post office was on the other side of the High Street, approximately seven buildings west of the White Hart Hotel (according to the census returns for the period). From within this building, the town's nineteenth-century postmaster, William Turner, also operated an upholstery and cabinet-making business. The inset shows insignia on the doorway of the 1930s post office.

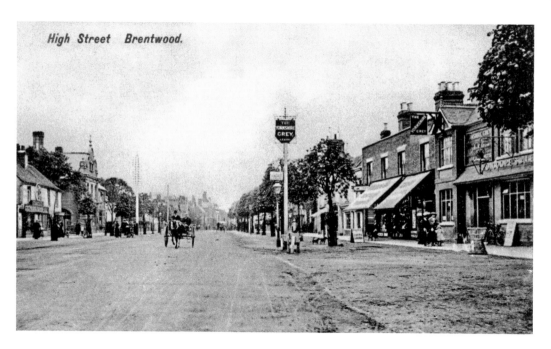

High Street Brentwood.

Yorkshire Grey, High Street (facing west), postmarked 1910

Originally known as The Ship until approximately the 1840s, the Yorkshire Grey was a popular Brentwood High Street pub. In 1908 the pub built its own bowling green behind its premises and a group of patrons (including the landlord) founded the Brentwood and District Bowling Club. The bowling club (and licensed trade) continued in the Yorkshire Grey until it closed its doors in the 1960s. The building was demolished in 1961, to be replaced by shops. The bowling club moved to its current location in the King George's Playing Fields.

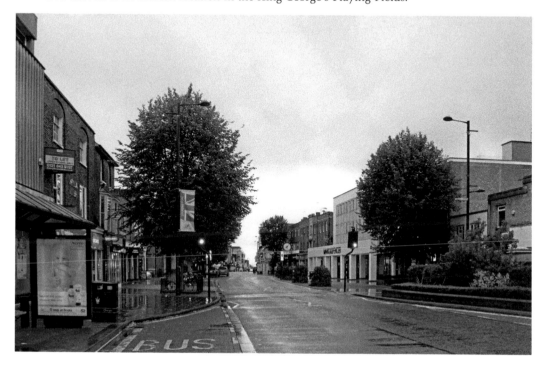

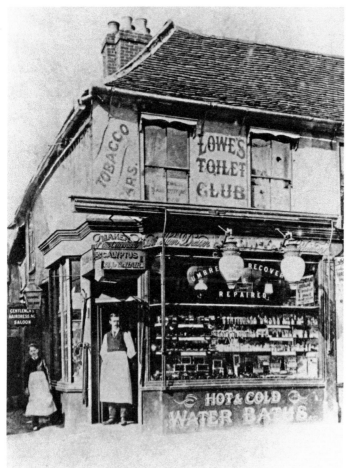

High Street, c. 1894
One of the many
shops on Brentwood's
Victorian High Street
was the Hairdressers
and Toilet Club owned
by M. Lowe in the 1890s.
The *Chelmsford Chronicle*
ran advertisements
throughout 1894:
'Brentwood Toilet Club.
M. Lowe, hairdresser &co.,
has every convenience
for conducting the above
business. Private saloons
for ladies and gentlemen:
or, if preferred, waited
upon at their own
residences. Special prices
for families.' The precise
location of Mr Lowe's shop
is unknown, as so many
of the older buildings in
the High Street have been
demolished to be replaced
by modern buildings. The
photograph below shows
one such block of the High
Street's modern buildings
built in 1938, just before
the Second World War.

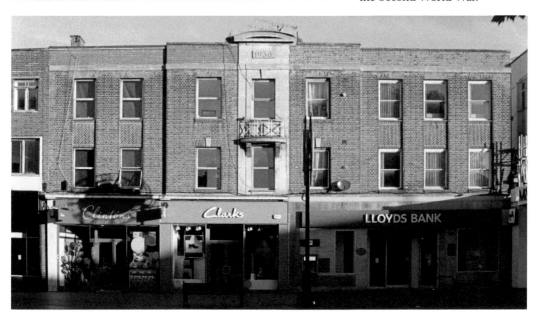

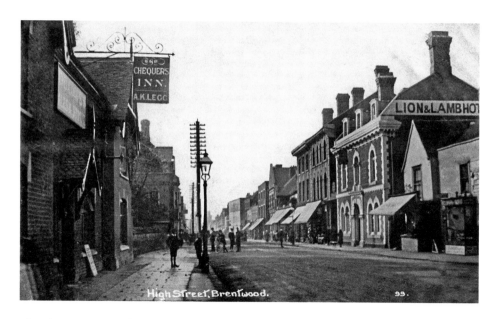

The Chequers Inn and the Lion & Lamb Hotel, High Street (facing west), postmarked 1918

The shops on the far right of both images were once a medieval hall house, built in the fifteenth century. Next to this is the Lion & Lamb Hotel, which was first mentioned in local newspapers in 1771, although it is likely to have existed in the town long before then. By the early 1800s, it was used as posting house for stagecoaches running along the Great Essex Road. The inn had extensive stabling for the coaches; in 1819 the proprietor advertised ten post horses for sale, along with three sets of harnesses and a chaise. On the other side of the road, the Chequers Inn (established in around the 1760s) was also used by stagecoaches; in 1773 the *Ipswich Journal* advertised that the 'Coggeshall Machine' ran three times a week from Coggeshall to Aldwich and it passed the Chequers Inn 'after breakfast in Witham'. Brentwood's use of stagecoaches died with the arrival of the great train age, but the two pubs continued into the twentieth century. The original Lion & Lamb Hotel burnt down and was then rebuilt in the 1930s; it became a retail unit in the latter part of the twentieth century. The Chequers Inn was demolished shortly before the Second World War.

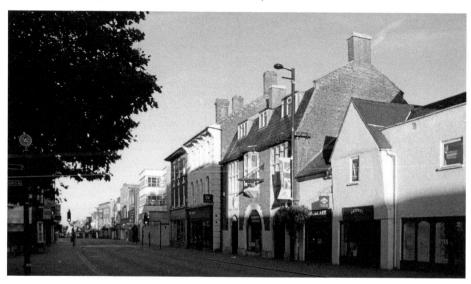

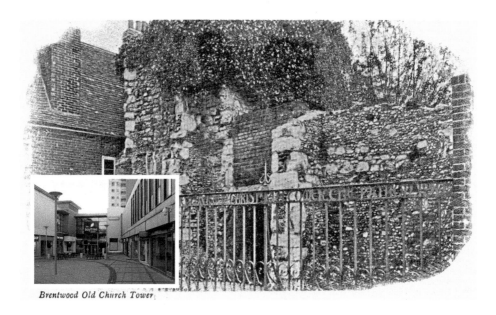

Brentwood Old Church Tower

Ruins of St Thomas's Chapel, High Street, postmarked 1905

The chapel in the High Street was founded in around 1221 as a chapel of ease to the main parish church in South Weald and dedicated to Saint Thomas à Becket. It was used by pilgrims travelling from the east of England and the Midlands, who were en-route to Kent to worship at the saint's shrine in Canterbury Cathedral. The church ceased operating in 1835 when a new parish church, also dedicated to St Thomas, was built nearby. The former chapel was then used as a boys' national school until 1869, when it was largely dismantled, leaving behind only a tiny portion of the original medieval building. Today, the land of the old chapel is Brentwood's 1970s Chapel High shopping centre, which was redeveloped in 2003–2005 and renamed the Baytree Centre (*see* inset). Pevsner's *The Buildings of England* scathingly comments that the centre is 'the sort of precinct development from which most Essex towns were mercifully spared'.

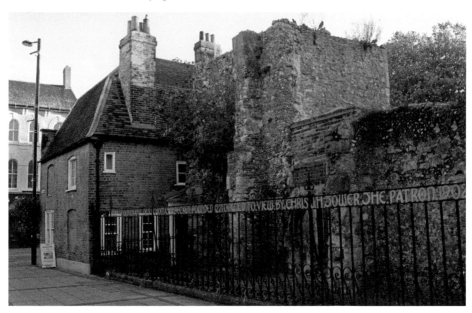

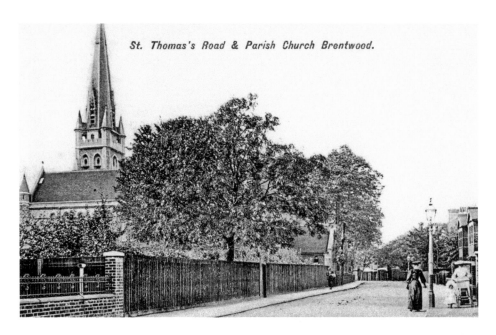

St. Thomas's Road & Parish Church Brentwood.

St Thomas of Canterbury Church, Saint Thomas Road, c. 1900s

Until 1873 Brentwood was part of the parish of South Weald, but from this year onwards became its own parish. In 1835, with the population of Brentwood increasing, St Thomas's Chapel in the High Street ceased operating as a chapel of ease and a new church was built. The new church was to the south-east of the old chapel, on land that was, at that time, used as a nursery garden. This church was of white brick but was badly designed and built, resulting in part of the tower falling down. From 1879 to 1886, the church was totally rebuilt at a total cost of over £22,000, with the foundation stone laid in February 1881 by local MP Octavius Coope, uncle of the church's architect E. C. Lee.

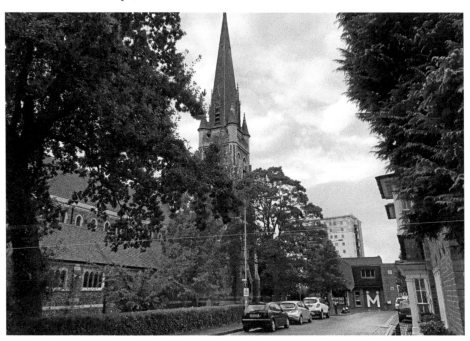

23

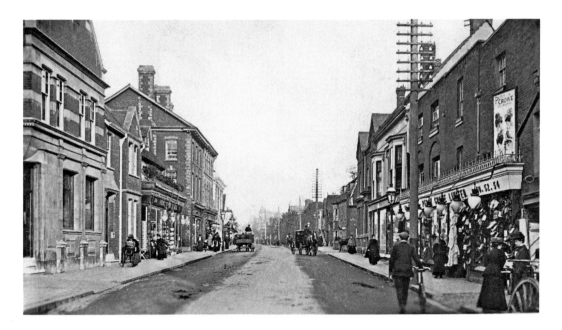

High Street (facing east), between 1905 and 1909

This animated street scene was photographed sometime between 1905 (when Percy Crowe took over the shop on the right) and the fire of 1909 at Wilson's Stores (the pre-fire building is seen in the centre of the image). The buildings on the right (from the horse and carriage to the front edge of photograph) have long since been demolished, to be replaced by a twentieth-century monstrosity. The buildings on the left of the Edwardian scene have not fared much better, with Barclays Bank occupying a modern site on the left of the scene and the modern building, which was once next to it, demolished and awaiting a new (hopefully aesthetically pleasing) structure. Fortunately, the tall buildings in the middle-left have not been demolished and are still recognisable today.

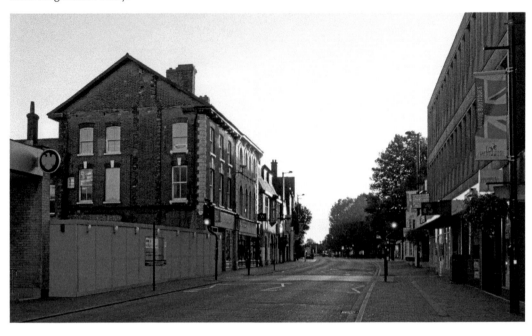

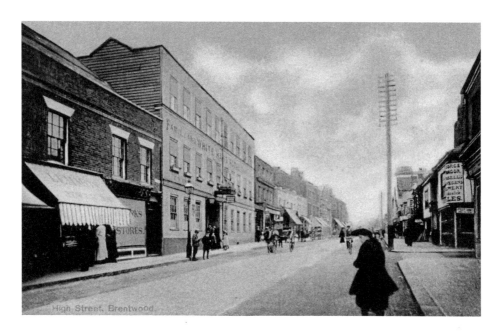

White Hart, High Street (facing east), postmarked 1908

The White Hart is one of the oldest buildings in Brentwood, with the current building constructed in the late fifteenth century. Its neo-Georgian brick front was added in the late nineteenth century. The inn existed prior to the fifteenth century. Richard II is alleged to have stayed here in 1392; hence the inn was named after his emblem, the White Hart. The inn was also used by early pilgrims on their way to St Thomas à Becket's shrine at Canterbury. In subsequent centuries it ran as a coaching inn for travellers journeying along the Great Essex Road. Today, pilgrims (of a different kind) still flock to the inn, although this time in search of the cult of celebrity and reality television programme *The Only Way is Essex*. The White Hart has been renamed the Sugar Hut and is now a nightclub where much of the filming takes place; the centuries-old inn has had a revival as one of the show's central stars.

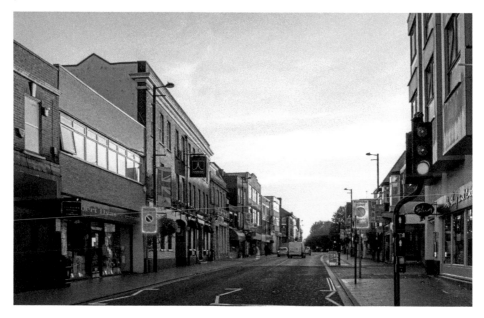

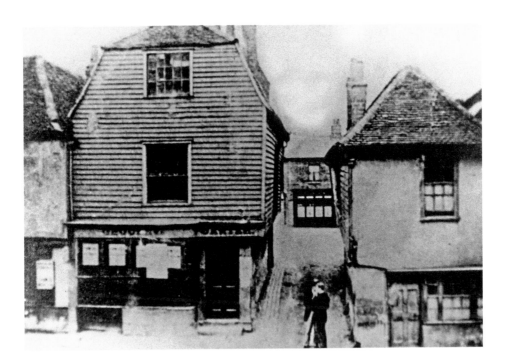

High Street (facing Crown Street), before 1893

In the centre of this Victorian street scene is the very narrow Crown Street. The weather-board building on the left of High Street and Crown Street was a Victorian grocer's shop belonging to George Carter. This building was demolished in October 1893. To the left of the grocer's shop, and out of shot, was the George & Dragon Inn. On the right of Crown Street is the original King's Head Inn, which has existed in the town since at least the late 1700s. The King's Head (shown above) was demolished in 1894 and new premises rebuilt further into Crown Street, at the corner with Hart Street. The King's Head and the George & Dragon shut their doors in the 1970s and were demolished.

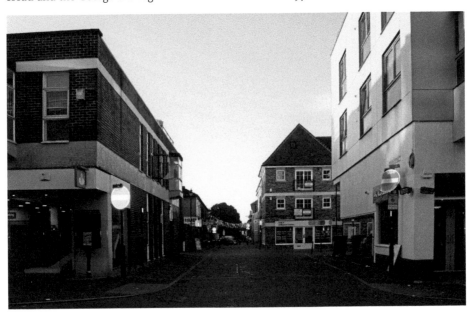

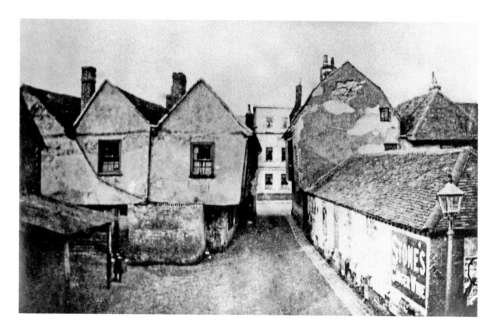

Crown Street (facing through to High Street), before 1893

This view is of the same buildings shown on the previous page but photographed from Crown Street, facing through to the High Street, with the White Hart visible through the gap in the buildings. The buildings either side of Crown Street (the back of the King's Head on the picture's left, and the back of Carter the grocers on the right) show how narrow the road once was until these buildings were demolished in the early 1890s. The low single-storey building in the bottom right (with the Stones's Ginger Wine bill-poster) was part of the stables to the High Street's George & Dragon Inn. Today, the White Hart can still be seen through the gap in Crown Street, but through a greatly widened road with modern buildings either side of the street.

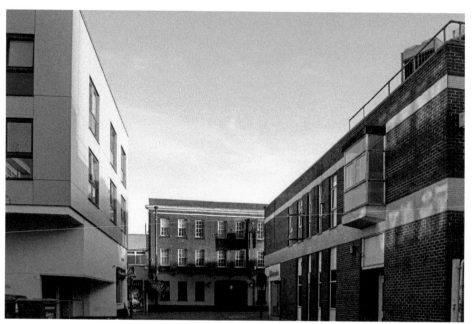

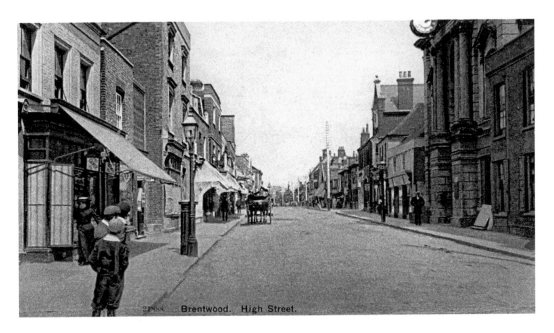

21888 Brentwood. High Street.

Town Hall and High Street (facing east), early 1900s

The building on the right with the clock was the Town Hall, built in 1864 at a cost of £1,800. It replaced the old Elizabethan Assize House. Brentwood's succession of local government bodies occupied the Town Hall from the 1860s until 1957 when the Urban District Council moved to a newly constructed building in Ingrave Road. The building in Ingrave Road is now the home of Brentwood Borough Council and was renamed the Town Hall in 2000. The Town Hall in the High Street was demolished in the 1960s, but the clock was saved and placed above the main entrance to the council's offices on Ingrave Road.

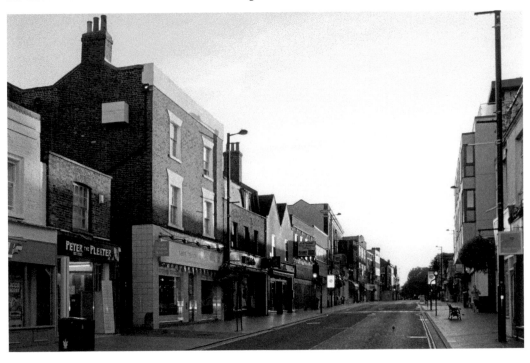

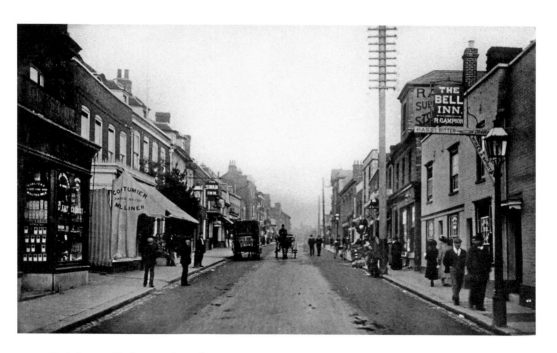

High Street (facing east), early 1900s

On the left is the Swan Inn, which is one of only two of the High Street's original public houses or hotels to have survived the progress of time. In the nineteenth century there were ten pubs along the road. The pub, originally known as The Gun, has been rebuilt several times over the centuries, the last time in the 1930s, but has been at this location in the High Street for many years. The Marian martyr William Hunter stayed at the inn the night before his execution in 1555. Like many other public houses within the High Street, The Swan Inn (*see* inset) was used as a coaching inn; the Colchester to London stagecoach changed horses at the inn. On the right side is the Bell Inn, another of Brentwood's old inns, which was first recorded in 1454. This pub suffered the fate of the majority of the High Street's inns and shut its doors in the early 1950s.

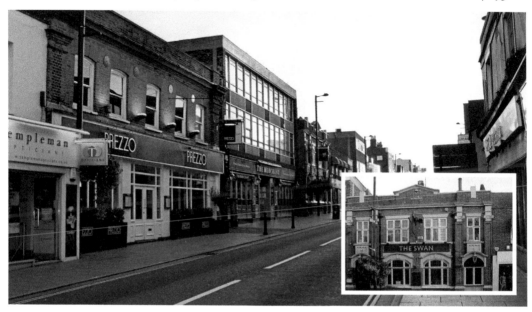

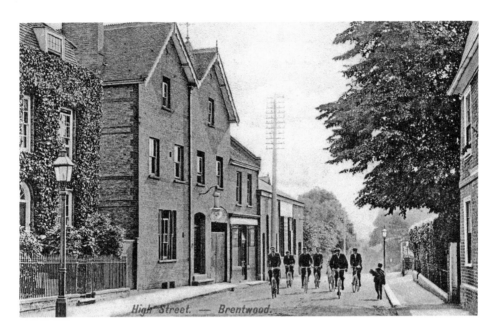

High Street (facing towards London Road), postmarked 1907

This part of the High Street is at its far westerly end, before it becomes London Road. The first building on the left is now the premises of a funeral directors, while the rest of the buildings on that side have long since been demolished and are now part of the land used as Westbury Road's car park. Cycling was a popular hobby in the late Victorian and Edwardian period. Local newspapers show that Brentwood had its own bicycle club from at least 1878 when there were thirty riding members and twelve honorary members. It is not known if the cyclists in the above photograph are from Brentwood's club but they look to be having a pleasant day out riding into Brentwood. The hobby was enjoyed by men and woman alike; there is one solitary female cycling behind the leaders in the top photograph.

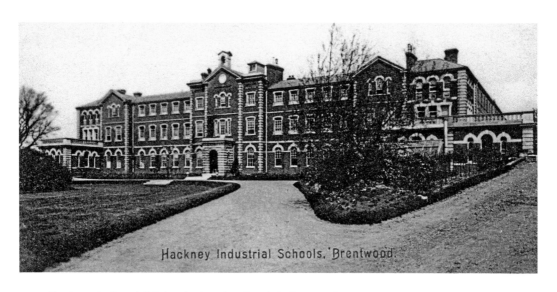

Hackney Industrial Schools, Brentwood.

Hackney Industrial Schools, London Road, before 1916

The Shoreditch Board of Guardians built the above building in the 1850s to train pauper and workhouse children from Hackney and Shoreditch in adult trades and occupations. In 1885, Hackney Poor Law Union took over the school. In the mid-1890s, the school was subject to considerable scandal when staff members were accused of acts of cruelty and abuse against the children. In 1894, female nurse Ella Gillespie was found guilty of several charges of cruelty and sentenced to five years in prison. The scandal rumbled on, with many reports of specific acts of cruelty to the children printed in national and local newspapers. The following year, the schoolmaster John Boreham, from Shenfield, was accused of abusing at least five boys in his care, but was acquitted. Despite the scandal, the school continued to be popular; by 1914 it had 560 pupils. In 1930 the school closed, and the building became St Faith's Hospital. The hospital closed in the 1980s. The former Victorian school for pauper children was demolished in 1998 to make way for British Telecom's offices, built in the 2000s.

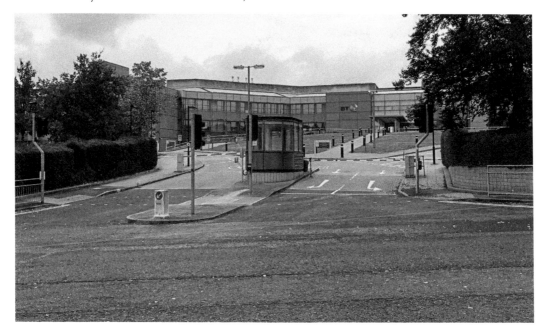

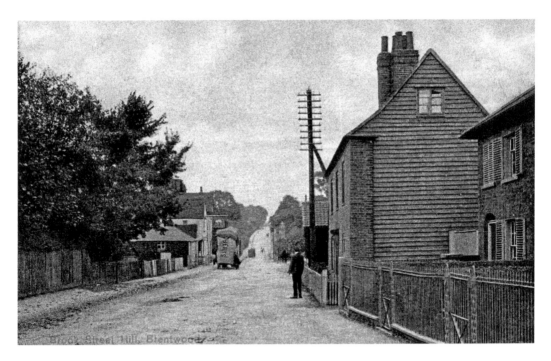

Brook Street Hill, London Road (facing towards the town centre), early 1900s

Once a rural lane out of Brentwood's town centre, Brook Street Hill in South Weald is now a continuation of Brentwood's London Road. Today it is a major road leading ultimately to the delights of the M25 via the infamous Brook Street roundabout. The pub on the left, the Golden Fleece, now belongs to a large national chain of restaurants, but its origins was that of a fifteenth-century hall-house.

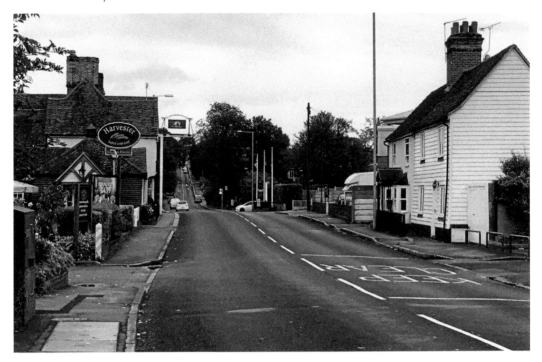

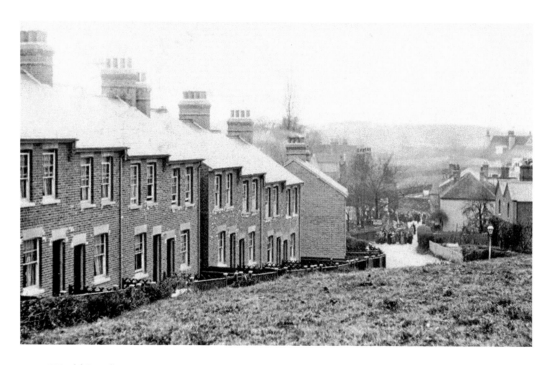

Weald Road, *c.* 1900s

Weald Road appears to have changed little in the last one hundred years. When they were first built this terrace of workers' cottages stood in relative isolation, with a small number of other Victorian terraces further up the road and older houses, such as Weald House, further down. However, there are now later twentieth-century houses all along Weald Road and a network of modern residential roads has sprung up all around. The grassy verge seen in the top photograph is no longer accessible to the public as it is now part of a garden belonging to a nearby house.

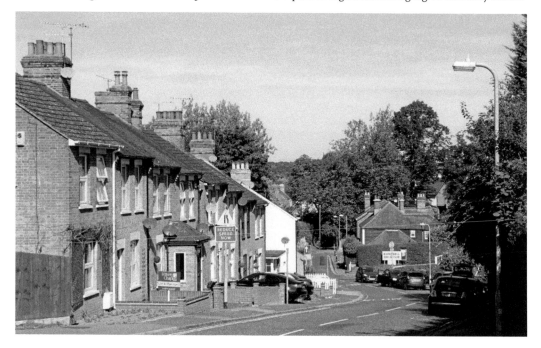

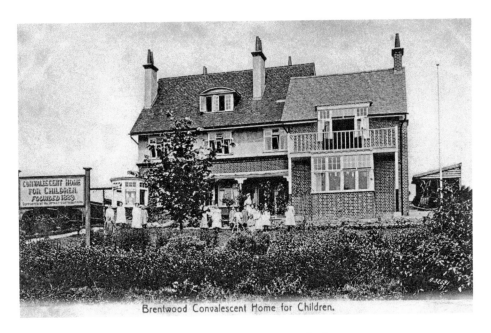

Brentwood Convalescent Home for Children.

Convalescent Home for Children, Weald Lane, postmarked 1911

A convalescent home for children from London was first proposed in the 1880s to mark Queen Victoria's Golden Jubilee in 1887 and was to be built on Shenfield Common. However, the proposals for a home on the common was not enacted upon; instead, from 1889, a children's hospital was established and run from a building located in Ongar Road. This building was large enough to admit ninety-two children during 1903 for an average stay of twenty-five days. In April 1904 a new home in Weald Lane was built and intended for twelve patients. All patients were females aged between four and fourteen years. The regulations stipulated that they must not have an infectious disease. The hospital ran throughout most of the twentieth century but the building has now been converted for residential use. The building is now known as Vincent Court and contains flats along with duplex apartments.

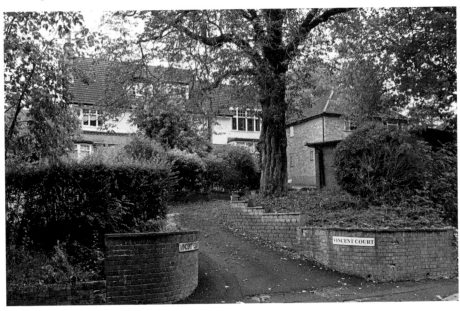

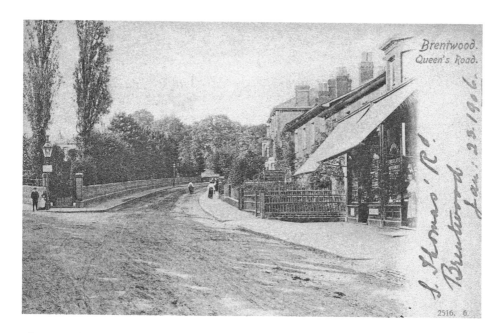

Kings Road/Queens Road, postmarked 1906

To the left and behind the photographs is Kings Road, and to the right is Queens Road. When the train line arrived in Brentwood in 1840 roads near to the station became popular with builders and developers. Some of the first houses to be built in Queens Road date from the mid-1840s; in 1845 one local newspaper reported that four newly built brick houses, each consisting of six rooms, were sold for a combined price of £575. By 1851, Queens Road was a popular place to live; the census returns for that year recorded that forty-eight families lived there (although the census is unclear as to how many were separate houses). According to this census, there was also a police station on the road ran by a superintendent and two other policemen.

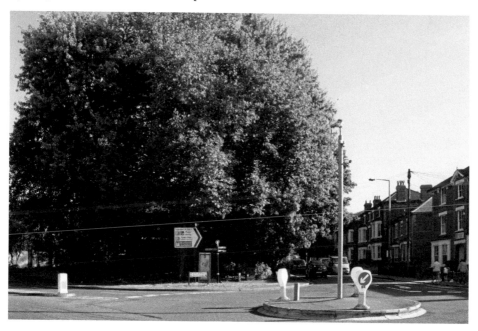

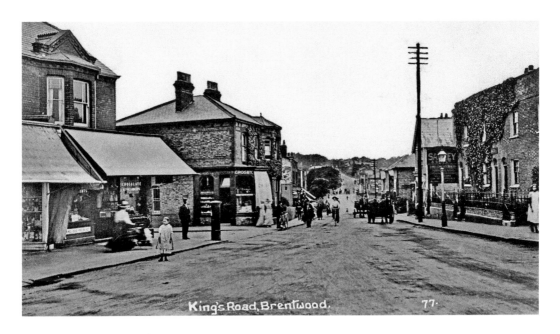

Kings Road, postmarked 1914

A map of the town dating from the 1770s shows that there was at least one brick kiln in this part of Brentwood. By the nineteenth century, there were several brickfields located in the road. They were built here as the road was outside of the main town centre, thus a location where industries centred on Georgian/Victorian brick-making could safely operate. The arrival of the train station in 1840, with its line to and from London, brought new industries to King's Road including shops and merchants' premises. Today, the train station is still a driver for the type of business that operates from Kings Road. These businesses include shops, modern hotels run by well-known chains and office blocks. Kings Road houses the headquarters of technology company Amstrad, which was founded by Lord Alan Sugar. Lord Sugar is now the star of hit television show *The Apprentice.*

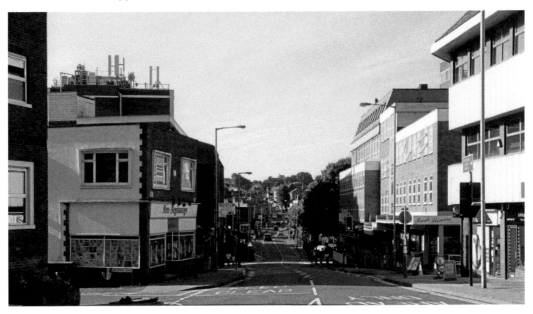

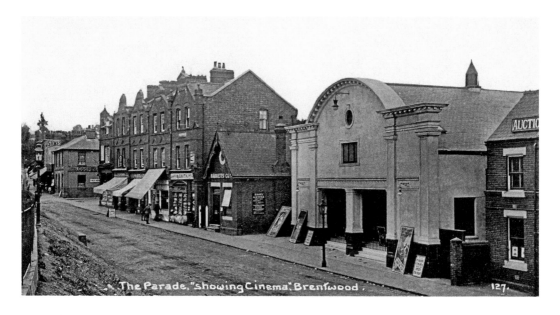

The Parade, Kings Road, postmarked 1919

The cinema in The Parade was built just after the First World War and closed its doors just over twenty years later, shortly before the Second World War. This was one of three cinemas located in the town during the twentieth century. The Palace Cinema was located in the High Street near to the Lion and Lamb pub and operated between 1914 and the 1960s (after being rebuilt in the 1930s). The third cinema, The Odeon, was built in the High Street in 1938 but demolished in the 1970s to make way for the Chapel High/Bay Tree shopping centre. The inset shows Albert Palmer & Son's boot and shoe repair business, which ran from one of the Victorian shops in The Parade (*c.* 1910s).

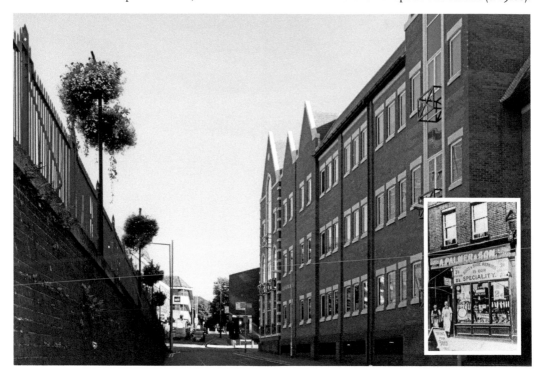

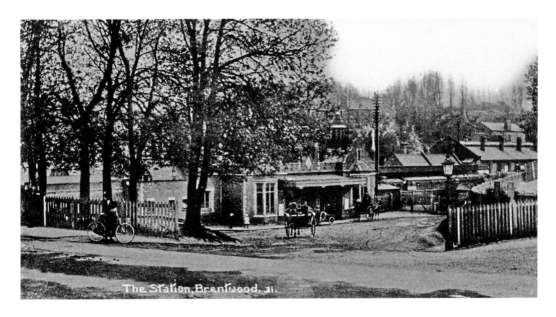

The Station, Kings Road, *c.* 1910s

The great Victorian age of train travel arrived in the town on 1 July 1840 and connected Brentwood to London via Romford. Over the centuries there has been much change to the station with the opening of new services and lines to other destinations within Essex. The top photograph shows the train station as it was in around 1900, while the bottom photograph shows the modern-day buildings. At the time of writing, the station is undergoing extensive redevelopment to accommodate the new Crossrail trains, which will be in service within the next few years. Seven Arches Railway Bridge (*see* inset) was built as part of the extension of the original London/Brentwood railway line to towns beyond Brentwood. The railway bridge spans the deep cutting that was dug by Victorian railway navvies and built from the bricks taken from a demolished Ingatestone mansion.

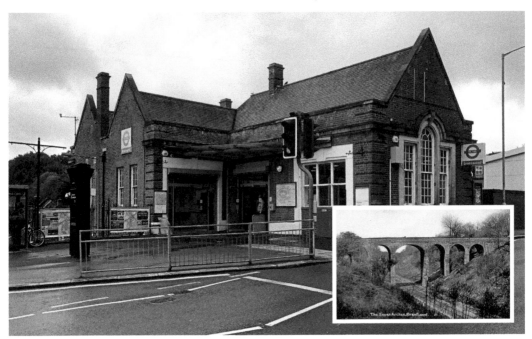

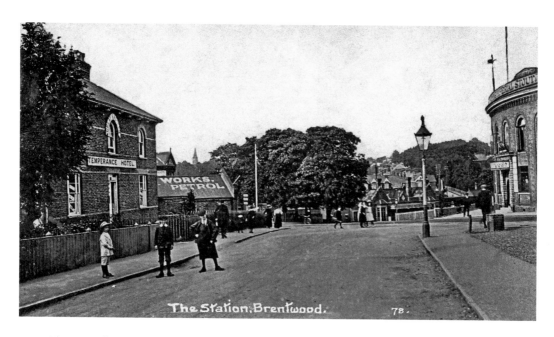

Kings Road, *c.* 1910s

While writing this book, it was difficult to determine if the street scenes of Brentwood's train station and the network of roads around Kings Road and Warley Road should be included in the chapter on the town itself or placed within the chapter on Warley. Officially, the station is in Great Warley and, for the majority of its history, the station was known as 'Brentwood and Warley'. The difficulty of the station's location is shared by others; local newspapers reported in September 2016 that the proposed parliamentary boundary changes (due to be made in 2018) will place the train station in the South Basildon and East Thurrock constituency, but the rest of town would be in the Brentwood constituency. The debate and controversy over Brentwood being separated from its train station is still rumbling on as this book went to press.

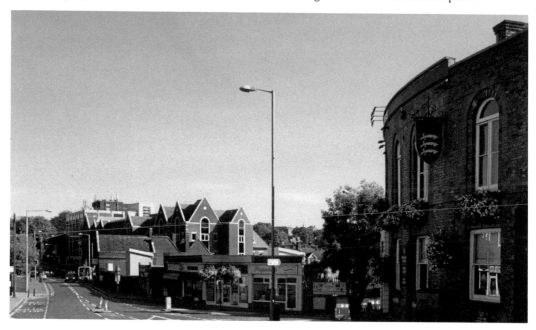

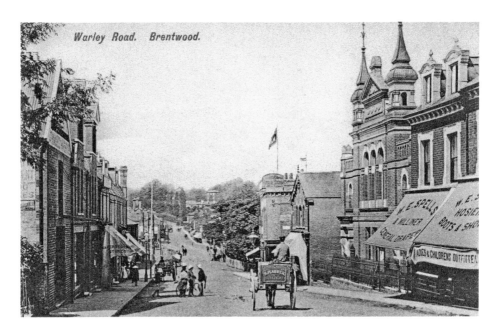

Warley Road. Brentwood.

Warley Road (facing the town centre), early 1900s

In the centre of the Edwardian scene, the flag belonging to the Essex Arms (sometimes known as the Royal Essex Arms) flies above its premises. The hotel was built in 1851. *The Essex Standard* reported that it was built at the cost of £2,500, financed by the hotel's first licensee, Joseph Ball. At this time, 'it contained 18 rooms replete with every convenience and that a want of accommodation of this kind was greatly felt by railway passengers and others; that stabling had been provided for 20 horses, with good coach-houses; and that there was a bowling green attached'. Today, the Essex Arms (*see* inset) is a pub rather than a hotel, and the stabling and bowling green have long gone. It is now a noted venue for the performance of live music.

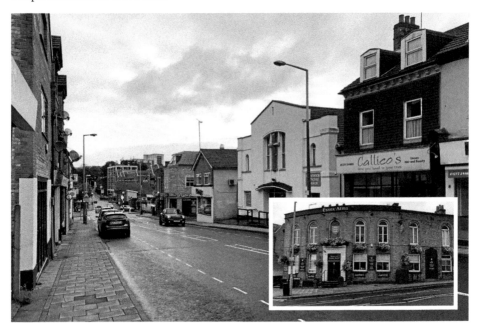

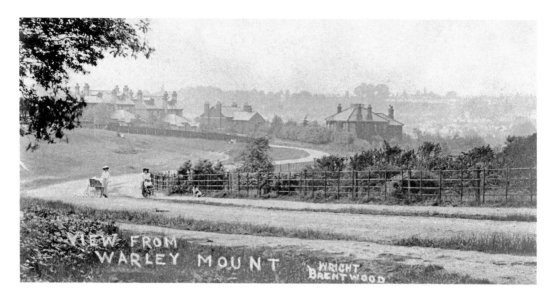

Warley Mount, postmarked 1906

Two Edwardian ladies push their babies in their prams up Warley Mount. Young children play games on the patch of grassland on the left side of the above street scene. Victorian and Edwardian villas had been built on the road, with their builders taking advantage of the trade and industry brought to Brentwood via its train service. However, there was only limited development by the time of the above photograph. The former grass areas are now heavily built upon with a mixture of houses from all the decades of the twentieth and twenty-first centuries. Some of the older Victorian and Edwardian villas are still present, but the majority of houses date from after the Second World War. In the distance of the modern photograph are the office and housing blocks of Brentwood, built during the twentieth and twenty-first century.

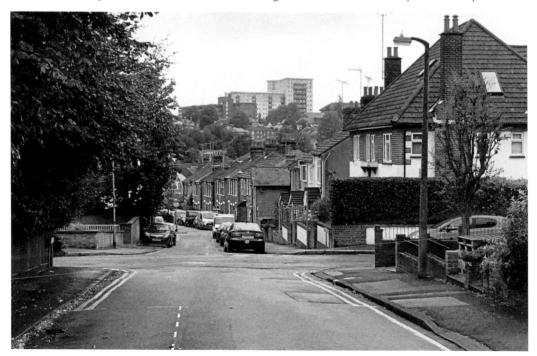

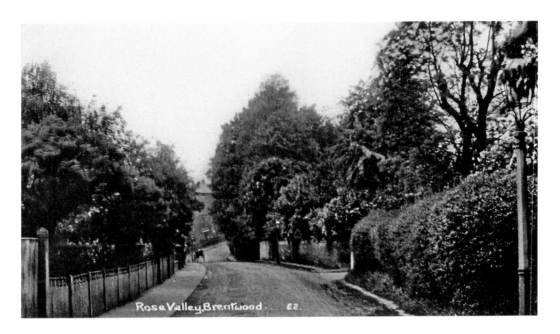

Rose Valley, c. 1910s

This road has been popular with builders and property investors since the Victorian period. In 1883, the *Chelmsford Chronicle* ran adverts from Messrs Beningfield & Paine announcing that plots of land on the first portion of the Rose Valley estate were available for purchase:

> Several plots of freehold building land, having an aggregate frontage of about 370 feet to Rose Valley, which afford valuable sites for the erection of first-class Villas... The importance of these sites can scarcely be overstated, situate as they are almost adjoining the Brentwood station which has such exceptionally good train service.

Today, houses on Rose Valley Road often appear for sale on the property pages of the internet. The excellent rail connections are still advertised as a selling-point for this road, much as they were over a hundred years ago. Both images were photographed at the train station end of Rose Valley, facing towards the station

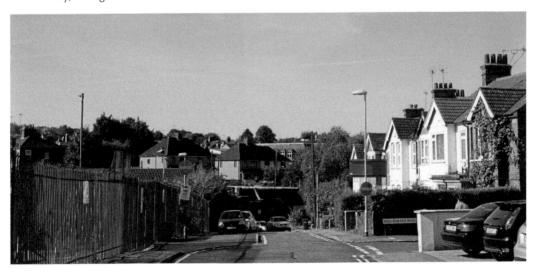

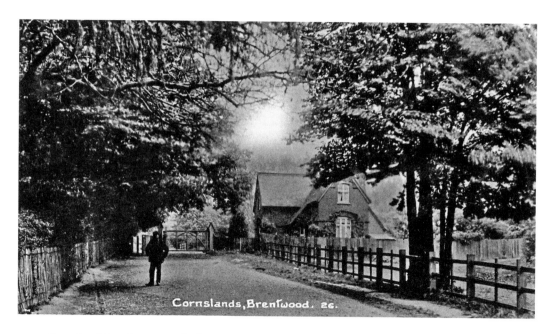

Cornsland Road, postmarked 1913

Cornsland is a road of two halves: the modern side accessible from Rose Valley and the older side from Seven Arches Road. The 1901 census shows that, at this time, there were only five houses in the older part of Cornsland: Woodville, Park House, Holmwood, Hillsted and the Priory (*see* inset). Each house employed a cook and several other domestic staff. The Priory is the oldest house, with its origins dating back to in the sixteenth century and then altered over subsequent centuries. More houses have been built in the road during the twentieth century and at least one of the older properties, Park House, has been recently divided up into several apartments.

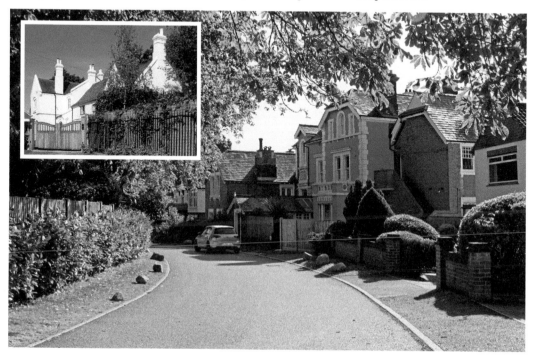

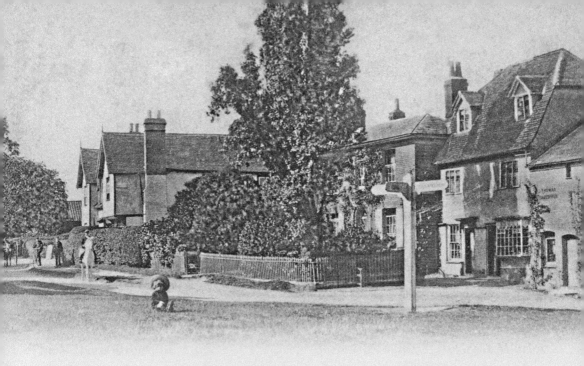

CHAPTER 2

Warley

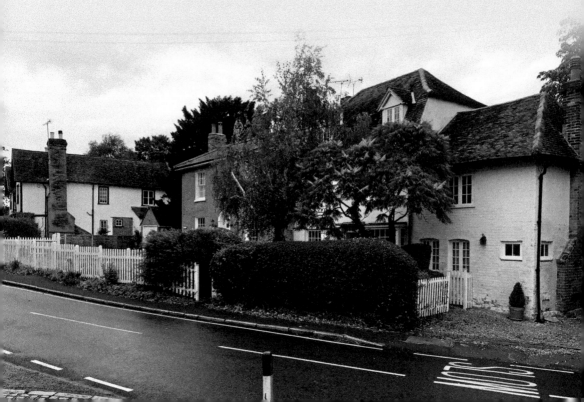

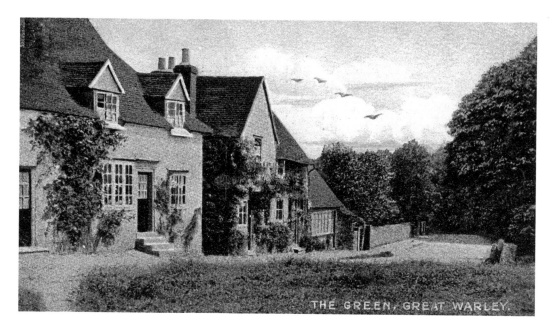

The Green, postmarked 1906

Great and Little Warley are two villages on the outskirts of Brentwood. Centuries ago, these were two totally independent and separate parishes with their own communities and churches. However, in recent centuries, the town of Brentwood has spilled into the villages so that it is difficult to determine where Brentwood ends and where (Great or Little) Warley starts. This expansion started during the building (and later extension) of Brentwood's train line (built in the parish of Great Warley), which first brought navvies into the Victorian parish, swiftly followed by a large number of builders and residents. Great Warley's village green (shown on the next page and partially here) was at the heart of the original medieval parish. The cottage shown on the far edge of the Edwardian image has parts that date from the thirteenth century; it is now aptly named Two Door Cottage.

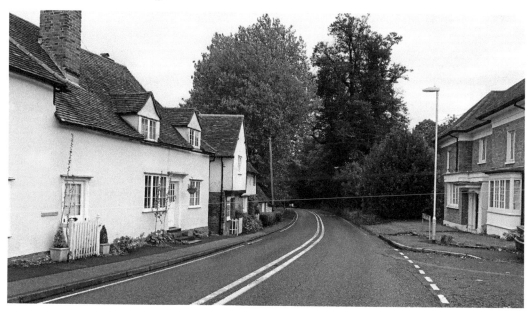

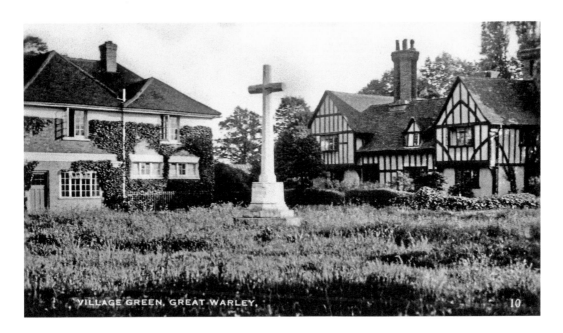

Village Green, after 1920

After the First World War, Great Warley's village green became the obvious place to commemorate the twenty-five war dead of the parish. The memorial was built in 1920 and partly financed by Evelyn Heseltine (1850–1930), the wealthy landowner and stockbroker who lived at the Goldings Estate (now known as the De Rougemont Manor Hotel). The memorial was unveiled by General Cecil Henry De Rougemont, Evelyn Heseltine's son-in-law. After the Second World War, a further six names were added to the memorial. The building to the left of the war memorial, Warleyside, was built in 1801 and was probably the married quarters for officers based at the nearby Warley army barracks. The building on the right is Wallets, which was built in the fifteenth or sixteenth century; at the time of photographing the modern image, it was being renovated.

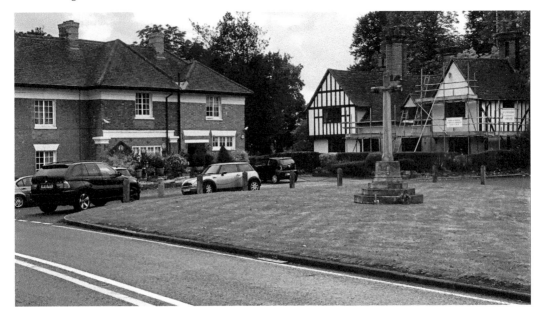

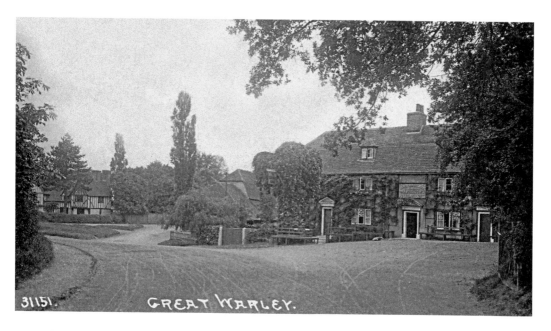

The Thatchers' Arms, c. 1910

The current Thatcher's Arms building dates from the seventeenth century, although the pub is thought to have existed in this location since at least the fifteenth century. At the time the top scene was photographed, the brewery used by the pub was the now defunct Hornchurch Brewery. By the middle of the eighteenth century, there were two public houses in the village; the Thatchers' Arms and the Magpie (later renamed as the Headley Arms). By the end of the nineteenth century, a further twelve pubs had opened within the parish.

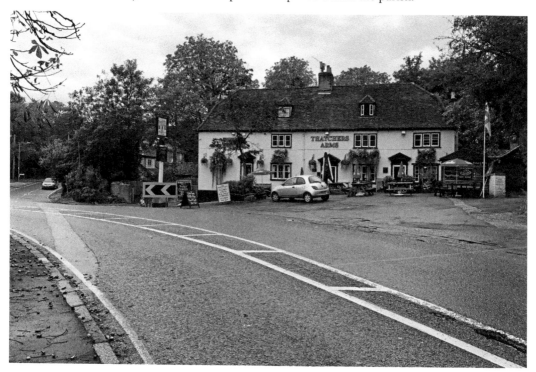

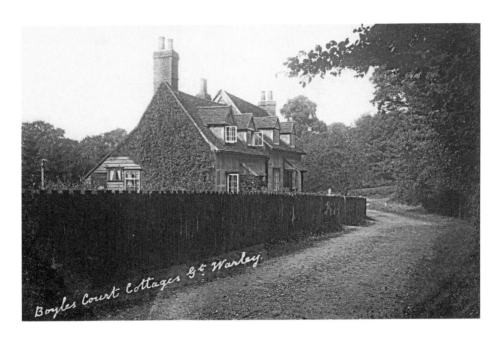

Dark Lane, early 1900s

The above photograph shows some of the estate cottages belonging to Boyles Court in Dark Lane; the lane got its name from the tunnel of elm trees that ran through the road. On the back of the above postcard, it is written: 'Residence of gardeners & grooms etc from Boyles Court'. Boyles Court was a manor house built in 1776 by the architect Thomas Leverton. In the twentieth century, the house became a children's home and a remand and assessment centre for boys. Later on, it was renamed Leverton Hall and was used as a secure unit for boys and girls. It once housed one of the killers of an abominable 1990s child murder. Leverton Hall shut its doors as a children's secure unit in 2014 and the house is currently empty. At the time of writing this book, there are plans to transform the house and its grounds into luxury housing. The huge skyscraper office blocks of Canary Wharf in the east of London are visible from Dark Lane (*see* inset).

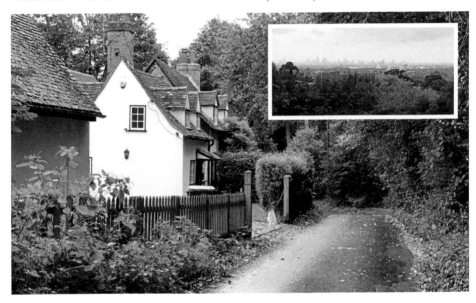

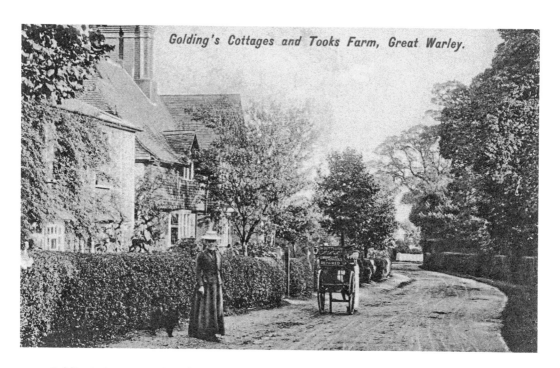

Golding's Cottages and Tooks Farm, Great Warley.

Golding's Cottage and Tooks Farm, postmarked 1908

Wealthy stockbroker Evelyn Heseltine arrived in the village of Great Warley in the mid-1870s, shortly after his 1875 marriage to his wife Emily Henrietta Hull. In 1881, he bought the estate of Golding's and lived in the main house, which was extensively remodelled and rebuilt by his architect as a brick-and-tile-hung building. His architect also designed many more buildings on his land including estate cottages and stables. After Heseltine's death in 1930, the estate was inherited by his daughter Muriel de Rougemont, who ran it with her husband and their surviving son until their deaths in the 1950s (another son was killed in the Second World War). After Muriel's death in 1967, the former main house of Golding's was converted into a hotel named the New World Hotel. The hotel suffered a devastating fire in 2001, which required most of the premises to be restored and rebuilt. In 2006, the hotel was renamed De Rougemont Manor Hotel.

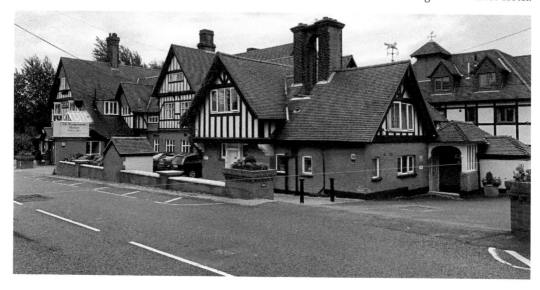

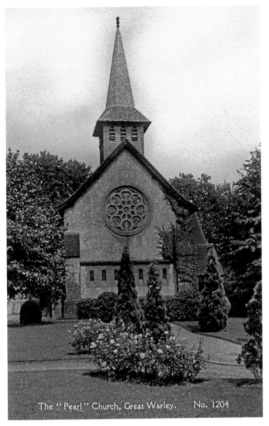

The "Pearl" Church, Great Warley. No. 1204

St Mary the Virgin Church, *c.* 1910
Nicknamed 'The Pearl Church', St Mary the Virgin Church was built in 1902–04, financed by Evelyn Heseltine of Goldings as a memorial to his brother, Arnold. The church's interior is in the Art Nouveau style and one of only three such churches in the country. Pevsner comments that 'it is a supreme exemplar of Arts and Crafts workmanship, overlaid with motifs from that most un-English of styles, Art Nouveau'. The church was built as a replacement to the original parish church of St Mary, which was situated next to Great Warley Hall. The inset shows the church's 1903 lychgate.

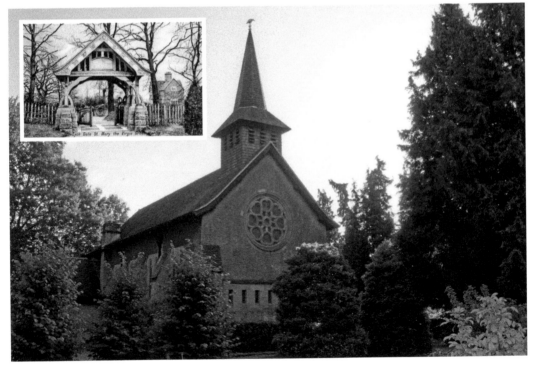

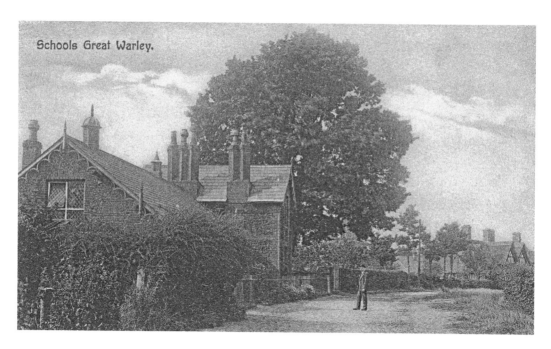

National School, Bird Lane, early 1900s

The school in Bird Lane was built in 1843, financed by a grant from the government and situated on land belonging to Charles Winn (Lord Headley). By the end of the 1840s, there were seventy-one pupils within the school, financed by subscriptions and money from the National Society for Promoting Religious Education. The school proved to be popular and it was enlarged in the 1870s to accommodate eighty-six children. In 1862, the schoolmaster's house was built next to it. The school continued throughout the first part of the twentieth century but was closed in 1968. It is now a large private residence with a separate annex and a swimming pool. Bird Lane also contains many of the estate cottages of Evelyn Heseltine's Goldings.

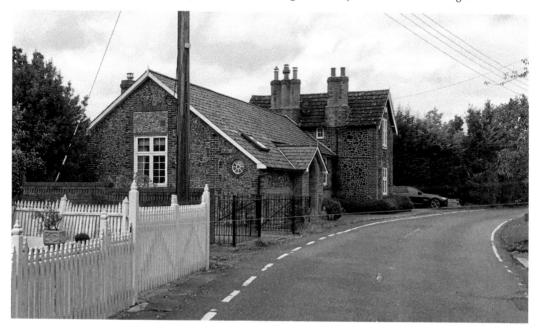

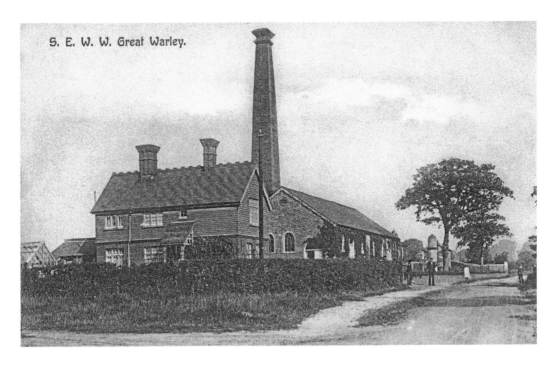

S. E. W. W. Great Warley.

South Essex Waterworks, *c.* 1900

South Essex Waterworks Company supplied Brentwood with the town's first mains water from the 1860s. To provide water for the ever increasing population, the company built its works in Great Warley, with the main pump house built in 1881 and further buildings added later the same decade. Today, the former reservoir, waterworks house and pump are office units and named Waterworks House and the Old Pump Works. The chimney seen in the top photograph has been demolished.

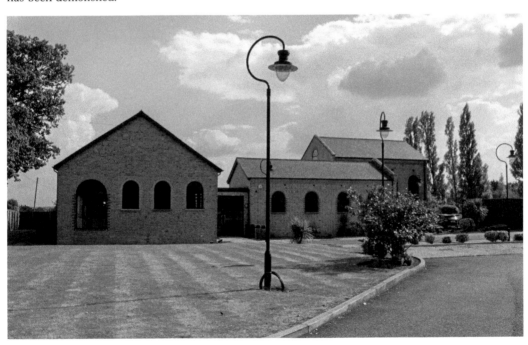

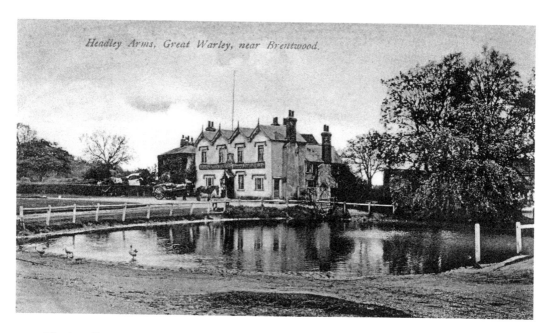

Headley Arms, Great Warley, near Brentwood.

The Headley Arms, Headley Common, early 1900s

Until the 1840s this pub was known as the Magpie, but was renamed the Headley Arms after the lords of the manor, the Lord Headleys. The building shown in the Edwardian image above was knocked down during the mid-twentieth century and rebuilt in a modern style, as seen in the bottom photograph. In 2011, the pub closed its doors but then launched as Indian restaurant the Headley Spice, which was opened by *The Only Way is Essex* (TOWIE) star Lauren Goodger. The restaurant is often used as a location set by the cast of TOWIE.

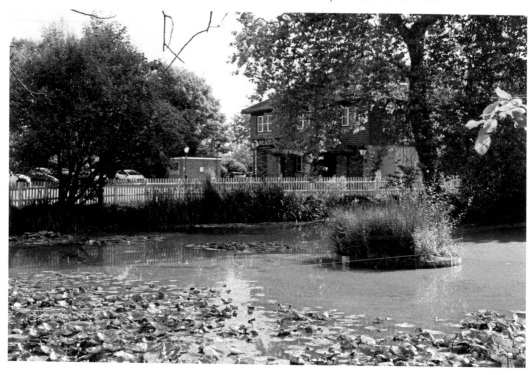

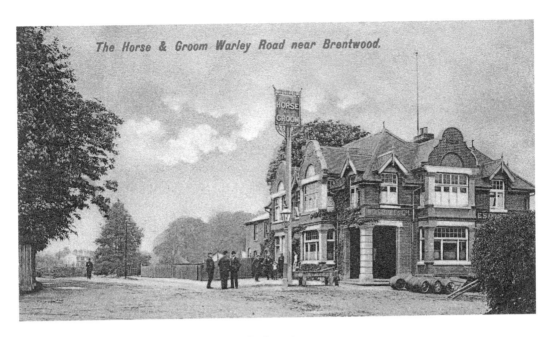

The Horse & Groom Warley Road near Brentwood.

The Horse & Groom, Warley Road, postmarked 1908

The Horse & Groom first opened its doors to the thirsty inhabitants of Great Warley at the end of the eighteenth century. Originally called the King's Head, it had changed its name to the Horse & Jockey by the time of a local newspaper dating from 1773. The first mention of it being the Horse & Groom is found in an 1801 local newspaper. With its location so close to Warley Barracks, it cannot be a coincidence that the daughter of one of the mid-nineteenth-century landlords married an army man of impeccable credentials. The *Suffolk Chronicle* reported in 1859 that Elizabeth, daughter of landlord Samuel Parker, had married Staff-Sergeant David McInnes of the 13th Light Dragoons. McInnes was 'one of the survivors of the gallant 600 engaged in the famous Light Cavalry Charge at Balaklava'. In the 2010s, the pub closed its doors and was boarded up for a time, but reopened as a Turkish restaurant called the Fat Turk. In September 2014, during its conversion into the restaurant, its roof caught fire.

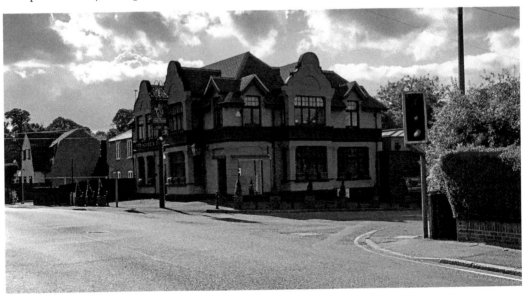

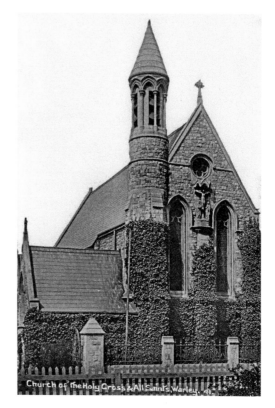

Holy Cross and All Saints Church, *c.* 1910
The Roman Catholic Church in Great
Warley was designed in the 1880s by
Frances W. Tasker, cousin to the church's
main donor, Countess Helen Tasker of
Middleton Hall, who gave £2,430 towards
its final cost of £3,986. The countess
was a generous benefactor towards
Catholicism in Brentwood. Her donations
paid for a convent to be established next
to the Catholic church (now cathedral) in
Brentwood. She was generous during her
life and after her death, with a contribution
made for the building of a school with
a girls' orphanage in its grounds and an
endowment towards the education of
orphaned boys.

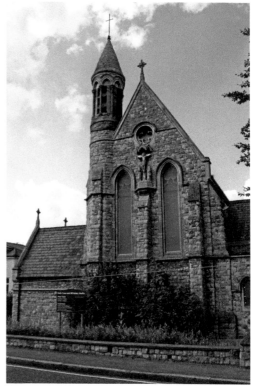

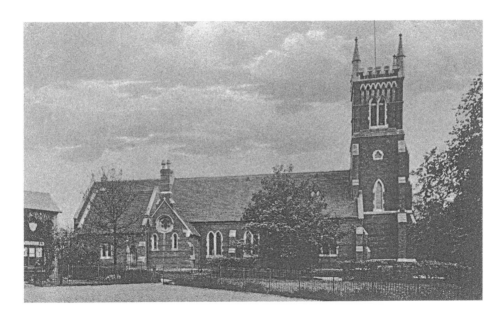

Christ Church, Warley Hill, *c.* 1910

Great Warley was an ever expanding parish in the nineteenth century. With the original church of St Mary the Virgin located in the south, an additional church was required in the north of the parish. Christ Church was built on Warley Hill in the 1850s and used as a chapel of ease to the main parish church. In 1854–5, a school was built next to the church on land owned by the East India Company. With the population increasing, the school had to expand in 1890s and then again twenty years later so that it could accommodate 270 pupils by 1911. When Essex County Council took over the school in the 1960s, a new school was built in Essex Way. The old school was eventually demolished in the mid-1970s.

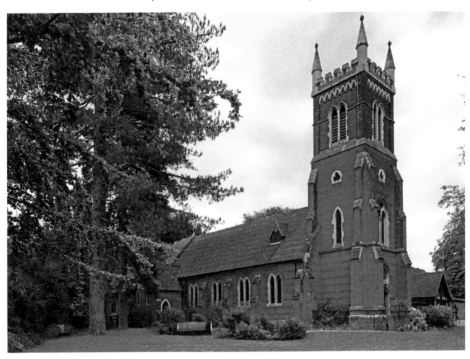

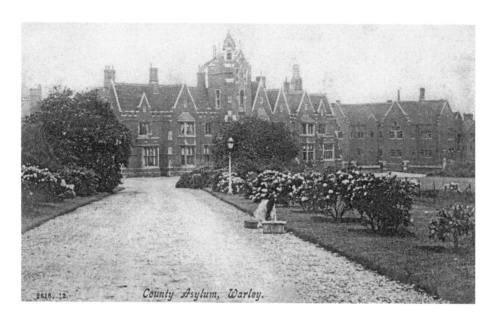

County Asylum, Warley.

The County Asylum, The Drive, postmarked 1905

Warley Hospital was originally known as the Essex County Lunatic Asylum and designed by the architect H. E. Kendall of Kendall & Pope in 1851–53. The asylum took patients from all over Essex with its original capacity set at 450 beds – 200 for men, and 250 for women. The asylum had its own chapel and substantial grounds including a farm and kitchen gardens. In the 1920s, the asylum changed its name to the Brentwood Mental Hospital and, by the Second World War, had grown substantially and could take 2,000 patients. It changed its name for a final time on its centenary in 1953 to Warley Hospital. The hospital continued as one of the county's chief hospitals for the mentally ill until 2001. After its closure, the hospital and chapel were converted into luxury houses and apartments with a NHS medical centre in the hospital's former grounds, and its farmland converted into Warley Country Park.

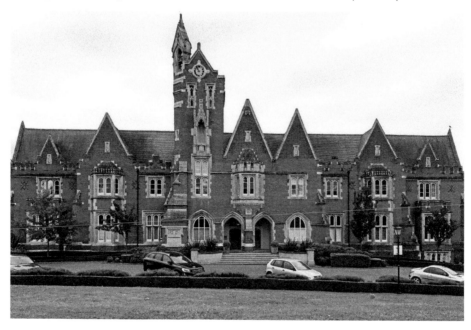

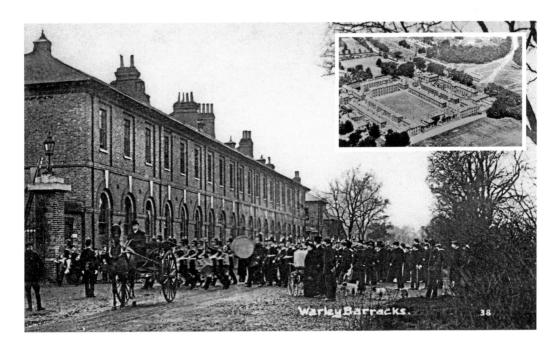

Warley Barracks, postmarked 1912

Warley has a long history of being a military base for various regiments of the British Army. From 1742 onwards and throughout the rest of the eighteenth century, a temporary camp, housing thousands of troops, was established on Warley Common. In 1805 the War Office purchased 116 acres of Warley Common and built the permanent barracks. Between 1843 and 1861, the barracks were owned by the East India Company, who built a chapel in 1857. During the 1860s, the barracks were purchased by the War Office. For nearly a hundred years between the 1870s and the time of their closure in the 1960s, the barracks became the home of the Essex Regiment, although other regiments also used the barracks. The barracks were closed in 1959 and most of the buildings demolished in the early 1960s to make way for Ford Motor Company's British head office. Today, all that remains of the old barracks is the Regimental Chapel, the officers' mess (now Marillac Nursing Home) and a gymnasium (Keys Hall). The inset shows Warley barracks from above.

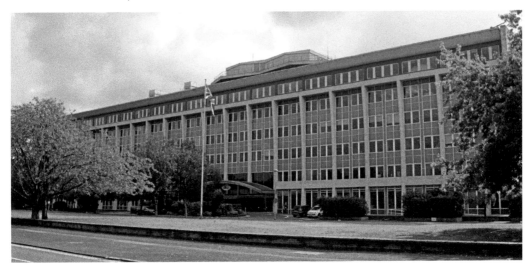

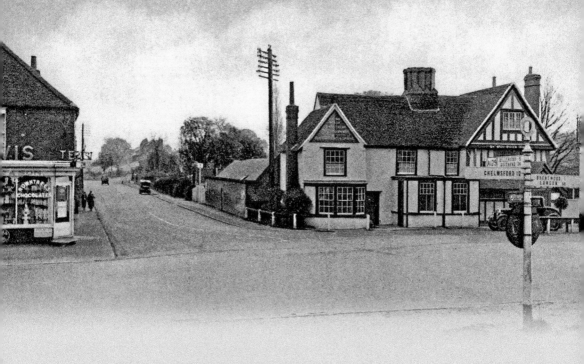

Shenfield

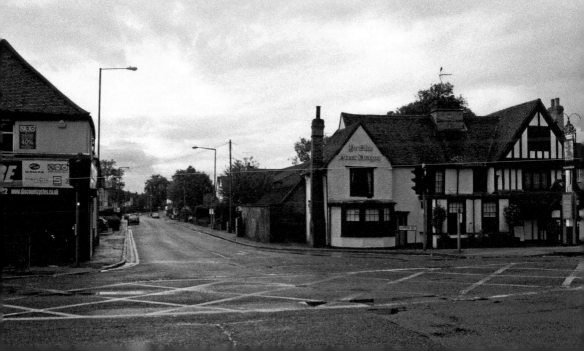

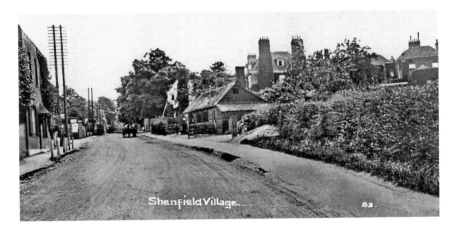

Shenfield Road, (facing towards Brentwood), *c.* 1910

In the centre of the picture, with the tall chimneys, is Shenfield Place. Designed by architect and polymath Robert Hooke (1635–1703), the house was built as a substantial residence at the end of the seventeenth century. In 1820, the house was offered for sale and an advert stated that it was

> A spacious brick built family house, together with a rich contiguous farm of about 98 acres, laying in handsome enclosures, late the residence and property of Richard Heatley Esq., deceased. The lands are of a superior quality, and chiefly meadow, ornamented with full-grown timber, and intersected by fine surface springs, forming together a most desirable Freehold Property, suitable for the residence of a Gentleman attached to agricultural pursuits in a good neighbourhood, and in the centre of field sports, with easy access (almost hourly) to the metropolis: the House contains four good proportioned rooms on each floor, with nine bed chambers and offices of every description, lawn and pleasure gardens, a capital walled garden and green-house, detached buildings, stabling, brick-built barn, and numerous other outbuildings, bailiff's cottage etc.

Today, Shenfield Place is a care home and its farmland has long been converted for residential use, with houses built in its former grounds. The top photograph was taken in Shenfield Road, which now has such an abundance of vegetation that the modern image had to be photographed from the back of Shenfield Place in Hall Lane.

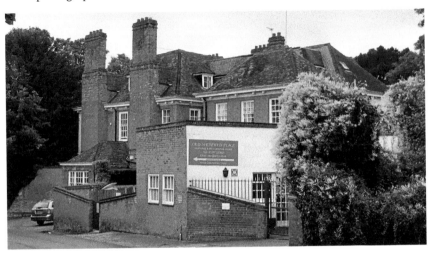

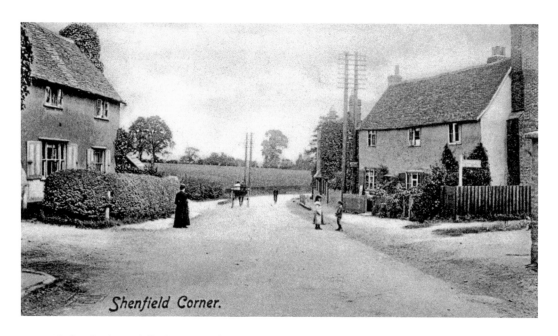

Shenfield Corner.

Chelmsford Road (facing away from Brentwood), *c.* 1900

The road from Brentwood through to Ingatestone, via Shenfield, was once the Great Essex Road, but is now called Shenfield Road (up until Tabor's Corner) and the Chelmsford Road (after Tabor's Corner). The Edwardian photographer stood at the junction of Hall Lane (to the left), Worrin Road (to the right) and Shenfield Road in the centre of the photograph. The bottom street scene is now familiar to those travellers who are on their way from Brentwood into Shenfield. What is less familiar is the plaster-covered Heatley Cottage on the right of the Edwardian photograph. Its plaster was removed in the mid-twentieth century to reveal its seventeenth-century wooden frame and modern brick-nogging was added to the bottom part. In the middle, the ivy-clad house end on to Heatley Cottage is Glanthams Lodge (*see* inset), a seventeenth-century red-brick building.

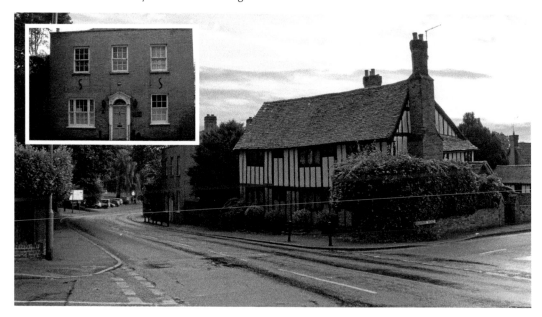

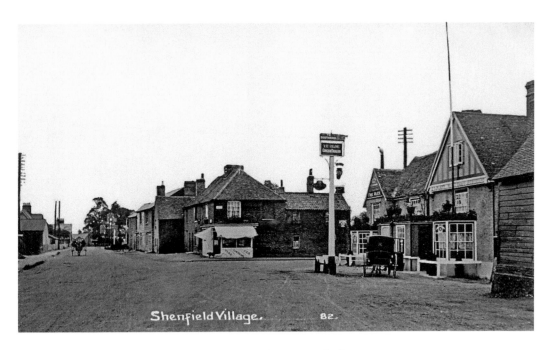

Chelmsford Road (facing away from Brentwood), postmarked 1913

On the right side of the photograph is Ye Old Green Dragon, a sixteenth-century coaching inn, which was used by stagecoaches running between London and Southend along the Great Essex Road. The turning on the right into Hutton Road marks the end of Shenfield Road and the start of Chelmsford Road. The junction between the three roads is known as Tabor's Corner and named after the family who ran the post office (which was also a bakery and confectionary shop) opposite the pub from the late nineteenth century until the First World War.

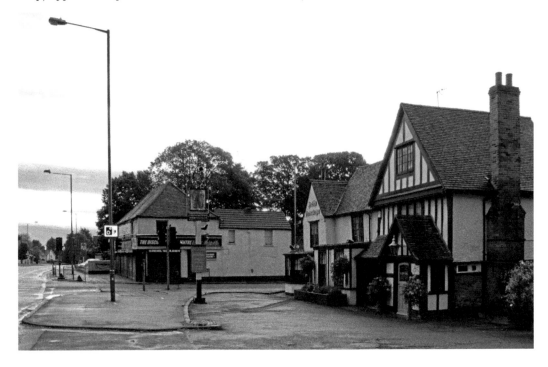

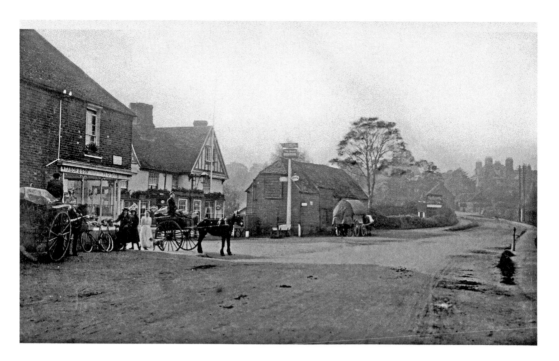

The Post Office and Ye Old Green Dragon (facing towards Brentwood), *c.* 1910
Between the post office (on the left of the vintage image) and Ye Old Green Dragon pub (centre left, behind the horse and cart) is Hutton Road, which marks the entrance into modern-day Shenfield. In front of the pub and running out towards the top is Shenfield Road, leading to the town of Brentwood, with the chimneys of Shenfield Place visible on the edge of the postcard. Before the arrival of the train station in the middle of the present-day town, this road, the Great Essex Road, was the main centre of Shenfield. In 1848, White's *Directory of Essex* recorded that there were just under 1,000 people living in the village. The modern-day town is substantially larger; the 2011 census recorded that Shenfield had grown to 5,432 inhabitants. Hundreds more houses are due to be built within Chelmsford Road so, in a few years' time, the population will expand significantly once again.

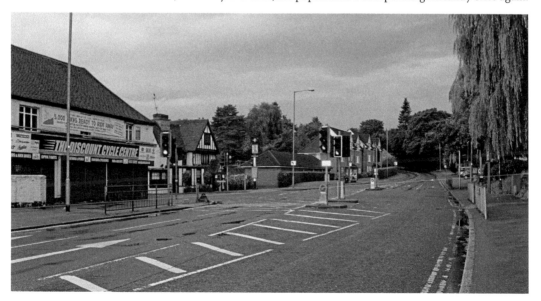

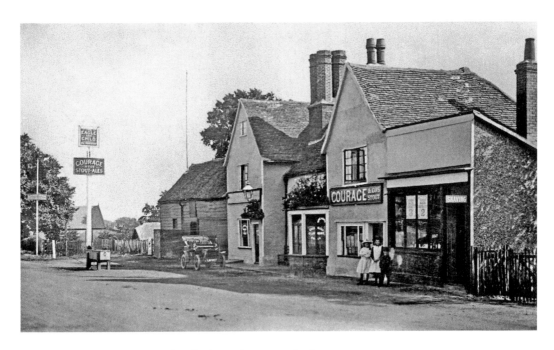

The Eagle and Child Inn, Chelmsford Road, postmarked 1914

An old coaching inn on the Great Essex Road, the pub is known by locals as the 'Bird and Baby', although there is also a much ruder version of its nickname. During the First World War, soldiers were billeted in the pub; on the back of the above postcard is the message: 'This picture is of our billet.' In the 1930s, the old pub was demolished and a new one built in its place. The road from Shenfield through to Ingatestone was the first road in Essex to be turnpiked by the Essex Trust in 1695. During the eighteenth and nineteenth centuries, there was a turnpike gate located along this part of the Great Essex Road; the Toll Bar cottage (*see* inset) still exists.

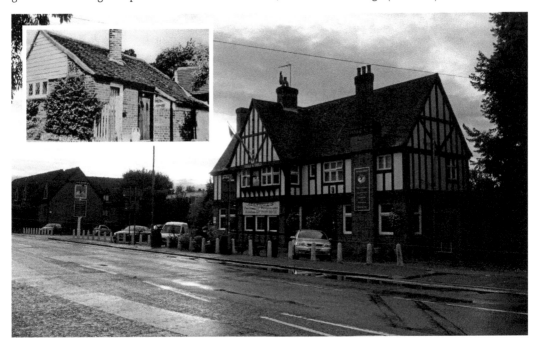

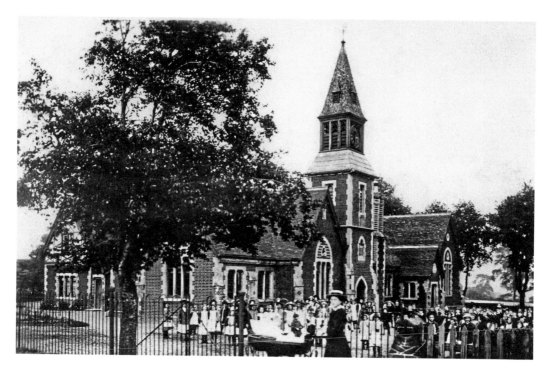

Shenfield National School, Hall Lane, early 1900s

Shenfield's National School was opened in 1865, with the initial number of pupils being 185, both boys and girls. A further block of buildings, including the tower (still present at the school today), was added in the 1890s. The school was seriously damaged by fire in 1936 and had to be extensively rebuilt at the cost of £2,500. Today, the school is known as St Mary C of E Primary School and is part of the Mid-Essex Anglican Academy Trust, with just over 400 pupils on the school roll.

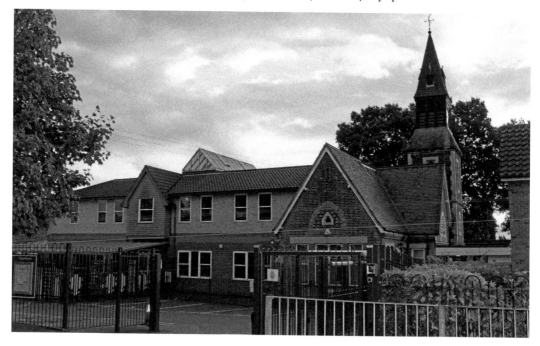

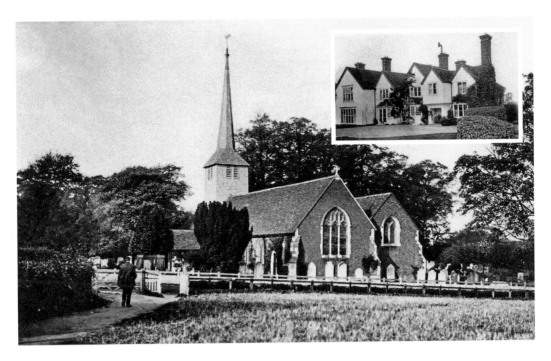

The Church of St Mary the Virgin, Hall Lane, *c* 1910s

There has been a church in Shenfield since at least the thirteenth century – a rector for the church was recorded to have been present in the village in 1249. The current building dates from the late fifteenth and early sixteenth centuries, with extensive modifications made at various points in the nineteenth century. The presence of the church and Shenfield Hall (*see* inset) next to it, which dates back to the sixteenth and seventeenth centuries, reveals that this area of Shenfield was the village's original medieval centre. At the time of the modern-day photograph, the tower was being extensively repaired.

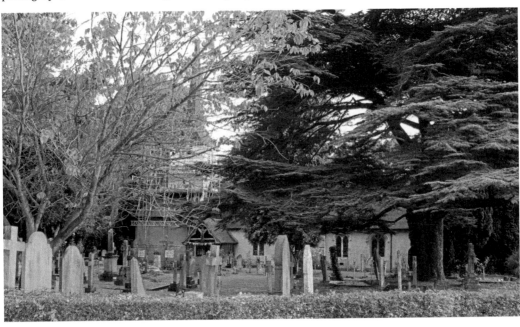

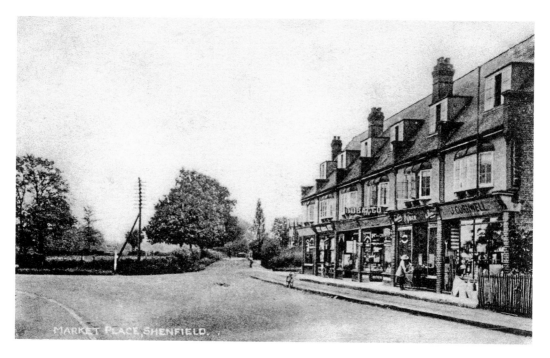

MARKET PLACE SHENFIELD.

Market Place, Hutton Road, *c.* 1900

Formerly known as Market Place, this road is now Hutton Road and has a mini-roundabout controlling traffic on Hutton Road and Priest's Lane (in the centre of the vintage photograph). Shenfield was not a market town and the trade and street directories of Victorian Shenfield do not record any such market. Moreover, there are no references to Market Place in local newspapers nor census returns dating from the Victorian period. So the choice of name for this area is unusual and appears to be an early twentieth-century creation.

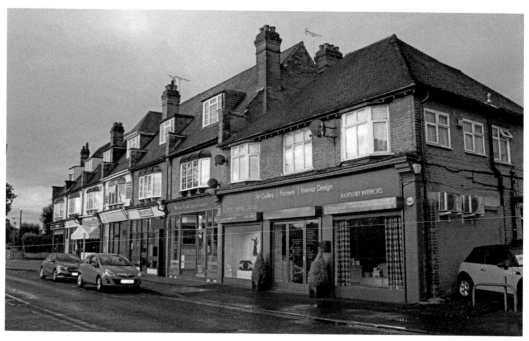

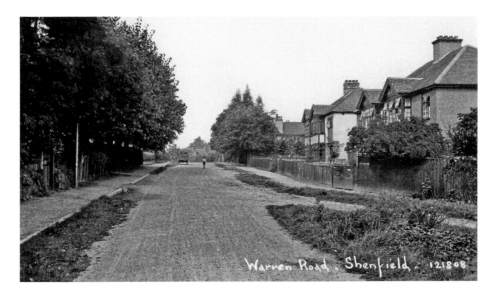

Worrin Road, *c.* 1920 and 1930

The Worrin family owned Glanthams Farm in this area of Shenfield during the Victorian period. William Worrin voted in the 1836 South Essex election, demonstrating that he was a wealthy landowner – one of only fifteen such landowners eligible for the vote in Shenfield. In the 1851 census he was aged sixty-two and described as being a farmer with 100 acres, employing four labourers and two boys. By the 1861 census, William was dead and the farm was run by his widow Mary and their son George. The Worrin's ownership of Glanthams Farm ceased in the early 1880s and Essex newspapers advertised that the farm was for sale:

> The very desirable Freehold Estate known as Glanthams situate at Shenfield near Brentwood, comprising a farmhouse and buildings, and about 87 acres of very first-class arable and pasture land and possessing considerable frontages to Priest's-Lane near Shenfield-common, adapted for building sites; and eight cottages.

Today, the former farmland is a very popular residential area and hundreds, if not thousands, of houses have been built on it. However, the area's past is still remembered in the street names of Worrin Road (sometimes misspelt as Warren Road) and Glanthams Road.

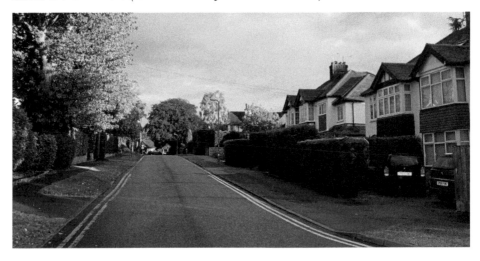

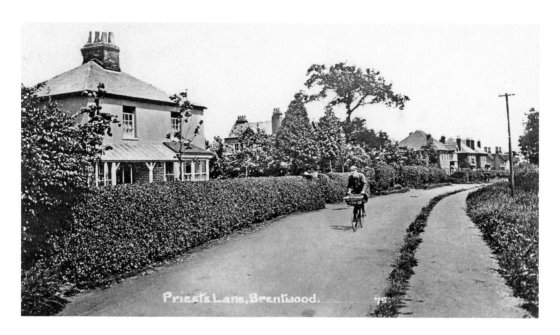

Priest's Lane, *c.* 1910

Priest's Lane is a long winding road full of houses both large and small. Some of these houses date from the end of the nineteenth century and the beginning of the twentieth century, while others are newer additions from the late twentieth century. Since Victorian times, it has always been a desirable place to live. In 1906, the *Chelmsford Chronicle* reported that three Edwardian villas – Edens, Norton, and Belmont – had all sold for the combined price of £1,170. Today's price tag for the Edwardian villas in the road are considerably more, with many currently costing nearly £1 million each.

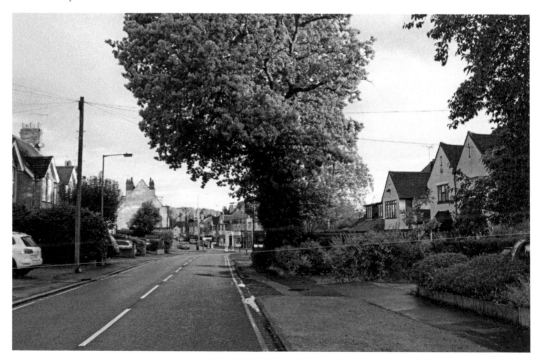

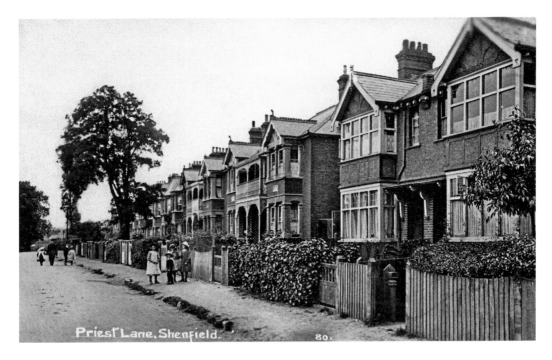

Priest's Lane, (facing away from Shenfield) postmarked 1917

During the night of 18 December 1917, the German's conducted an air raid on Kent, Thanet, Essex and London, with enemy aircraft passing directly over Shenfield. During the raid, Sister Madeline Elsie Bates, a nurse with the Voluntary Aid Detachment Service, who was home on leave from France, went outside to the veranda of her aunt's house in Priest's Lane. She was hit by shrapnel from one the Gotha's bombs and died from her injuries a few days later. Miss Bates was buried in Shenfield's parish church with military honours. According to newspaper reports no air-raid warning was given, despite considerable gunfire being heard in the road, and the dropping of at least five bombs in the area, with one bomb causing a large crater in Priest's Lane.

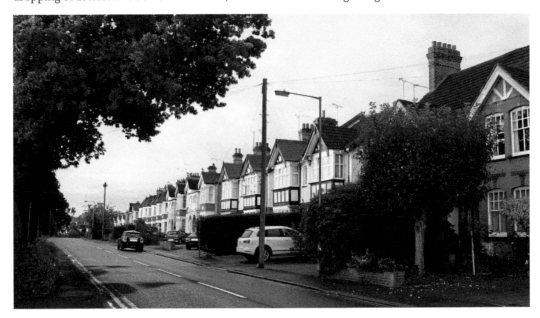

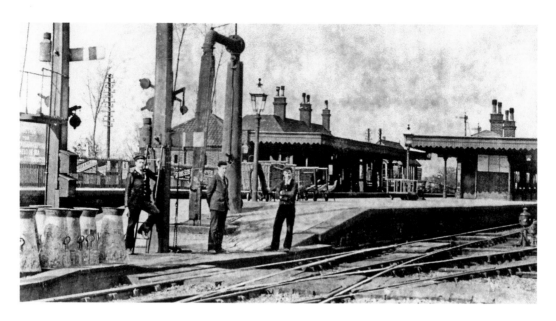

Shenfield Station, early 1900s

The original station in Shenfield was opened in 1843, bringing trains to and from London and Colchester. In its early years the line was unsuccessful so the station closed in 1850, only to reopen in 1887 with the intention of serving both Colchester and Southend (the latter line opened in 1889). At this time, Shenfield had only three platforms: two for London and one for Colchester and Southend. By the mid-1930s, a new suburban service into London via places such as Ilford, Romford and Gidea Park commenced. To serve this additional line, the station increased from three platforms to five. Now known as Shenfield Station, from 1887 until 1969 the station was called Shenfield & Hutton Junction. The station is now part of Greater Anglia's network of east of England stations and is one of its most popular. For the year 2013/2014, 3,314,120 passengers either started or ended their journey at the station. With the opening of the new Crossrail service in a few years' time, Shenfield's footfall is likely to increase dramatically. The modern image was photographed in autumn 2016 and shows some of the Crossrail construction work.

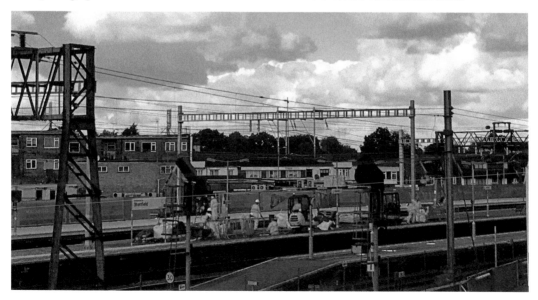

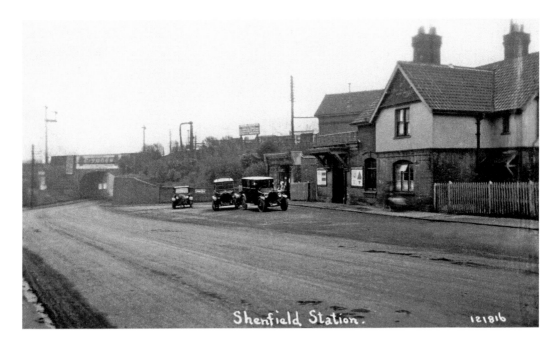

Shenfield Station, *c.* 1910/1920

The vintage scene shows Shenfield's old Victorian station with its small booking hall, which was located next to the station master's house (on the right). In the distance, the narrow bridge over the road brought trains to and from London and Colchester or Southend. By the mid-1930s, the station shown in the top photograph had been demolished and replaced with new buildings. The station also increased its tracks and platforms to cater for the new suburban service into London. To serve this additional line, a wider bridge was built over the road. The station was remodelled again later in the twentieth century to the buildings that are seen today. Outside today's booking hall is the forecourt, which is always full of cars and taxis. At one stage in the 1990s and 2000s, there was a small road sign in the drop-off area, which wonderfully proclaimed that the area was for 'Kiss and Drop'. With the imminent arrival of the new Crossrail rail link, connecting the east of England with towns to the west of London, Shenfield Station will be a major hub and the planners' current intentions are to remodel the forecourt into a pedestrianised piazza.

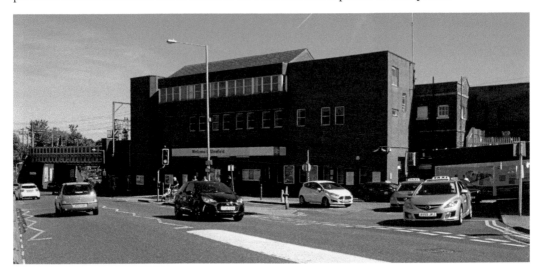

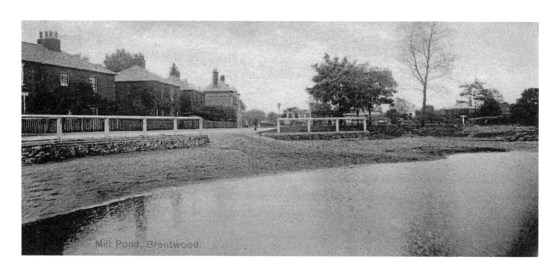

Mill Pond, Brentwood.

Mill Pond, Shenfield Common, postmarked 1915

Named after the windmills that once stood on Shenfield Common in the Victorian era, the Mill Pond was used both for practical and leisure purposes. Carts used the pond after the local smithy fitted a new wheel. The pond was also enjoyed by young lads fishing and young people ice skating. During Christmas 1887/8, the *Chelmsford Chronicle* reported:

> The sharp frost covered the pieces of water in the neighbourhood with ice and many of the more adventurous spirits sought amusement in skating. There was a rush for the Mill Pond on Shenfield Common, but to prevent the spoiling and breaking up of the ice before it attained sufficient solidity, one of the conservators devoted himself to the task of keeping people off. After he left, however, late in the afternoon a large number of lads disported themselves on the pond.

Further newspaper reports regularly recorded accidents when skating, including five young people who got a drenching in the pond when the ice gave way at Christmas in 1891. Skating on ponds is no longer recommended; in modern times former industrial and leisure pursuits have given way to nature. The pond is now a haven for wild birds, ducks, and insects.

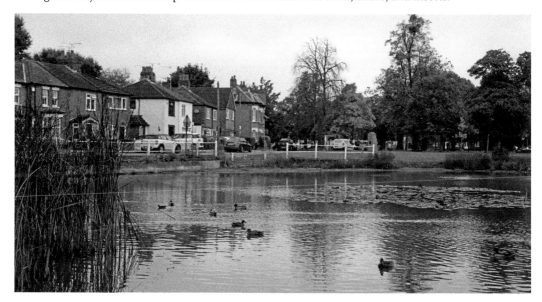

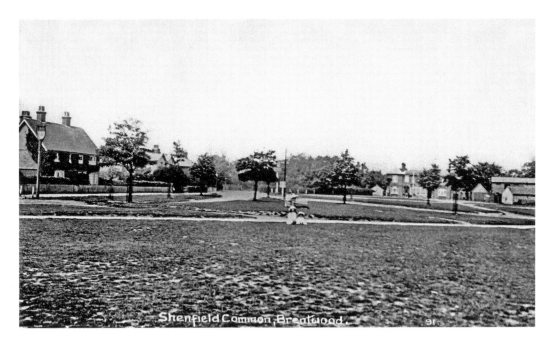

Shenfield Common (facing towards Brentwood), early 1900s

Known to many recent local residents as the Ye Old Logge Italian restaurant until it closed in 2000, the building on the left of the top photograph was once the Foresters Inn. The building burnt down in the 2000s and its site is now a block of apartments (seen at the left edge of the bottom photograph). Towards the right of the top photograph is the original building of another of Shenfield Common's pubs, The Artichoke. This was rebuilt in the twentieth century and is now a Toby Carvery.

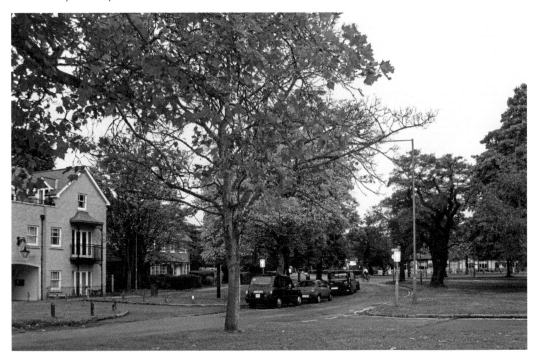

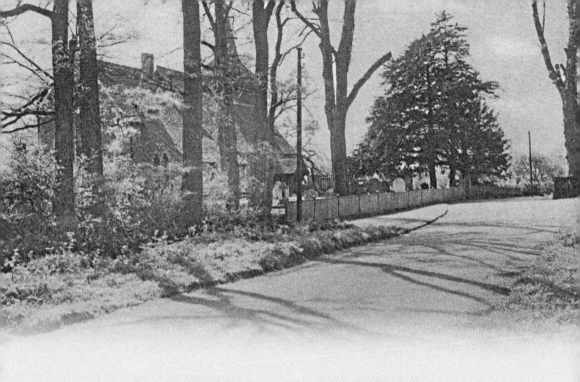

CHAPTER 4

Hutton

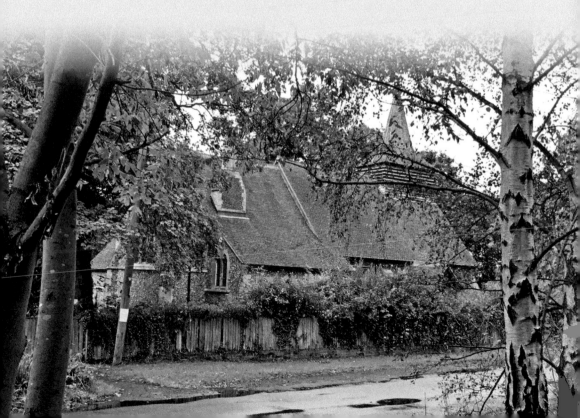

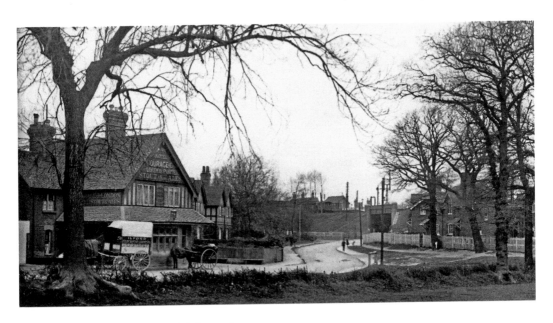

The Union Junction Hotel, Rayleigh Road, c. 1900

In the distance is the railway bridge adjacent to Shenfield Station, the bridge demarcating the end of Shenfield and the start of Hutton. The pub shown in the photographs is now known as the Hutton Junction and buildings such as a modern office block and a petrol station have been built between the pub and the railway bridge. Progress moves at a fast pace; during the course of writing this book, the petrol station, just visible in the bottom photograph, was demolished and replaced with a well-known luxury mini-supermarket. On the right side is the entrance into Alexander Lane. White's 1848 *Directory of Essex* recorded that Hutton was 'a pleasant village on the road between the two towns, 3 miles East of Brentwood, and 2½ miles West of Billericay, has in its parish 449 souls and 1699 acres of land, watered by two sources of the river Wid'. The population of Hutton, with its excellent housing stock and first-rate rail connections into London, has increased significantly since the reign of Queen Victoria.

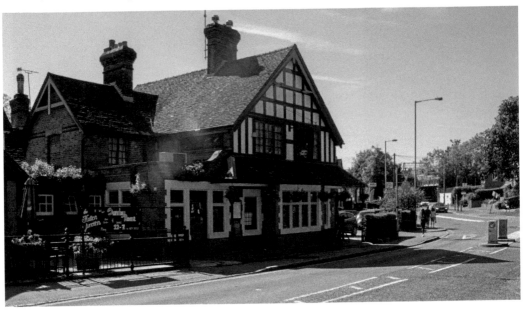

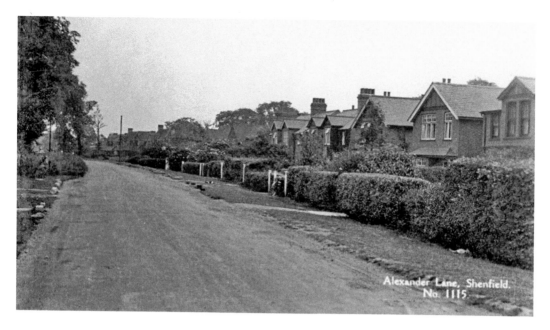

Alexander Lane, *c.* 1920

Despite the railway bridge seeming to be the marker between Shenfield and Hutton, it is hard to know where one place ends and the other starts. Part of Alexander Lane falls within the Hutton side of the railway line before it joins Rayleigh Road, while the rest is on the Shenfield side and joins Chelmsford Road. The above photograph states that Alexander Lane is in Shenfield, but today's property pages on the internet express that the road is in Hutton. Whether Hutton or Shenfield, this road first appeared in local newspaper reports in the 1860s and 1870s. However, the road's name was not recorded in census returns until 1881, when a total of eight houses were documented, presumably the railway workers' cottages at the junction of Rayleigh Road and Alexander Lane.

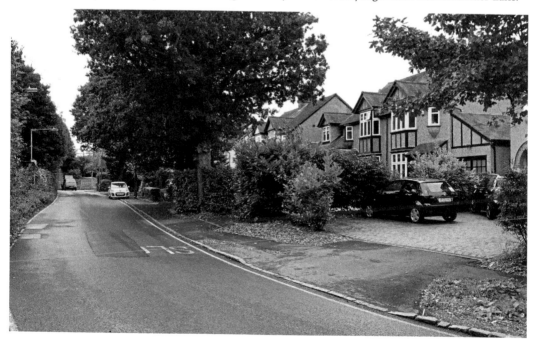

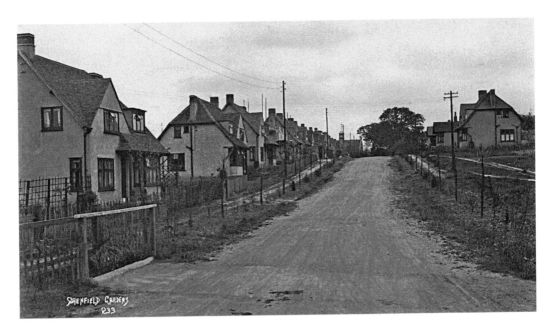

Shenfield Gardens, postmarked 1929

Near to the junction of Alexander Road and Long Ridings Avenue is the small private road Shenfield Gardens. The postcard's date shows that by the late 1920s, while most of the housing plots on the road had been built upon, there were still some vacant plots ripe for new houses. At the end of the road in the top photograph and in the distance is the clock tower of Hutton Poplars School's dining hall. Today, this small side road has been comprehensively developed with more houses and has matured into being a very pleasant road with established trees and vegetation. The former dining hall is one of the few buildings of Hutton Poplars School that has escaped demolition, but it is no longer visible through the abundant summer foliage of Shenfield Gardens.

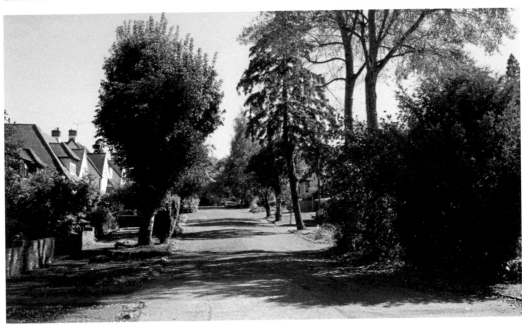

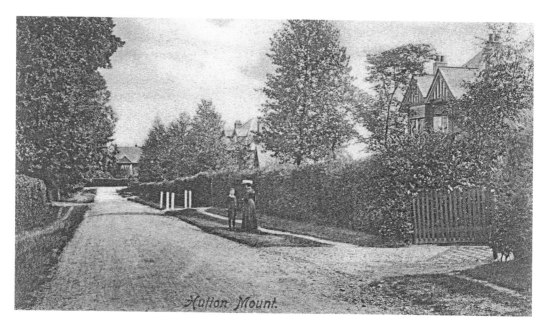

Hutton Mount, c. 1900

Today one of the most affluent and exclusive areas of Essex, Hutton Mount's popularity started in the late nineteenth and early twentieth century. The photograph above shows some of the luxurious and well-appointed Edwardian villas. By the time of the 1901 census, the majority of inhabitants of Hutton Mount were professionals with the heads of houses including solicitors, architects and surveyors, banking staff, managers and the financial officer for the City of London Police. The census returns also reveal that the majority of houses within the area employed live-in domestic staff including nurses, cooks, parlour maids, nursery nurses, grooms, governesses, and gardeners. Today, houses in Hutton Mount command sums in the multi-million-pound price range and are so exclusive that even Google's car-mounted cameras do not enter its network of roads. Behind the abundant trees, with their evergreen leaves, lies opulent houses and luxury mansions.

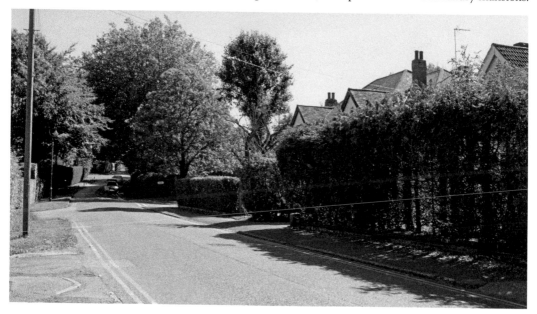

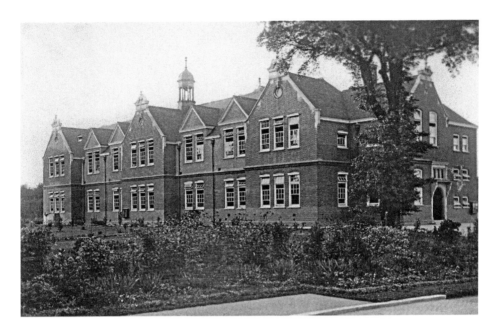

Poplars School, *c.* 1910

During the final years of the nineteenth century, Poplar Board of Guardians decided to sell their Forest Gate training schools because of their unsanitary state. Chairman of the Board George Lansbury, a social reformer, paid a visit to rural Hutton and liked what he saw. At Lansbury's instigation, Hutton Industrial School (also known as Poplar Union Training School) was built in 1906 at the cost of £160,000. Originally founded as a residential school for pauper boys from Poplar, the school eventually accommodated both boys and girls based around the concept of a 'cottage home'. George Lansbury (1859–1940) later became the leader of the Labour Party and is also of note for being the grandfather of Hollywood actress Angela Lansbury. The school closed in the 1980s and the majority of its buildings were demolished. Today the area is known as Hutton Poplars and contains extensive new housing. The inset show that the bell tower is still at the top of the old school, which is now an adult education centre.

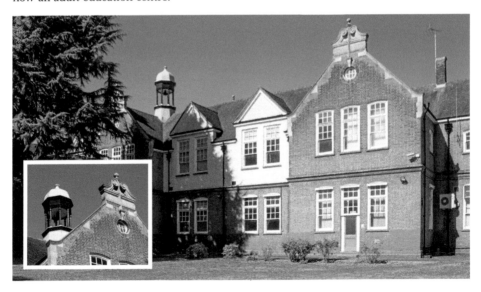

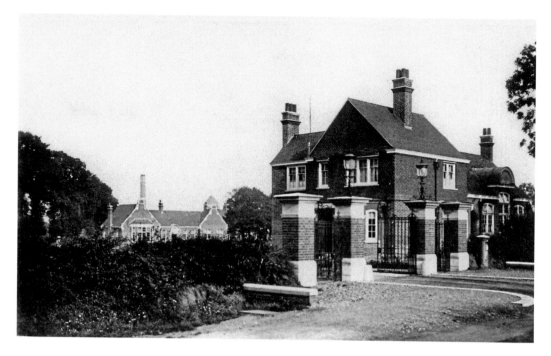

Hutton Poplar Lodge, *c* 1910

Today, only three buildings remain from the days of George Lansbury's school: the building above, formerly the porter's lodge but now available to be hire by clubs and societies; the building on the previous page, now an adult education centre run by Essex County Council; and the boys' dining hall, now a venue for private and corporate events. The inset shows Hutton Poplars Hall, formerly the boys' dining room.

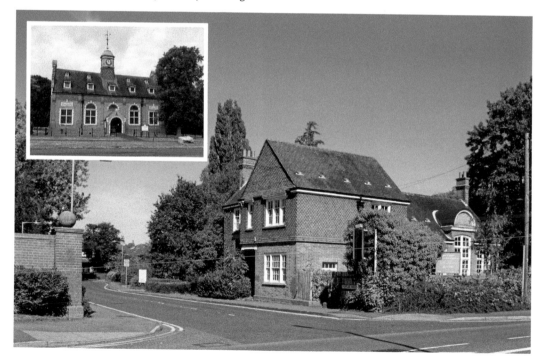

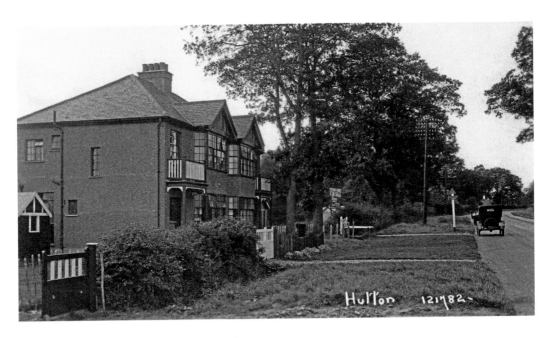

Rayleigh Road (facing Shenfield), *c.* 1920/1930

The top street scene was photographed just after the houses on the left were built; the 'For Sale' notice next to the second house proclaims that the builder was H. W. Page of High Road, Hutton. The scene shows the main road through Hutton from Shenfield to Billericay to be a sleepy road with little traffic. Today, two speed cameras have to be used to stop cars racing through this part of Hutton. In the past, this section of the road was called Hutton High Road, but the entire road is now Rayleigh Road.

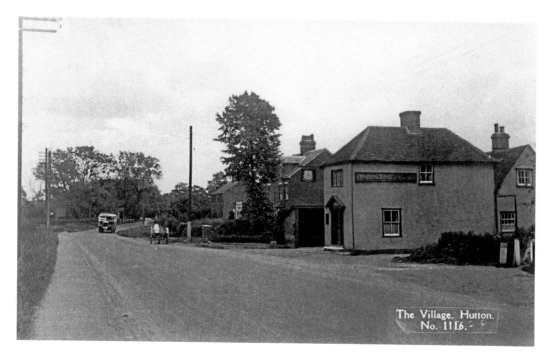

The Village, Hutton.
No. 1116.

The Chequers Inn, Rayleigh Road (facing Billericay), c. 1920

There has been a Chequers Inn in Hutton since at least the mid-1700s when the *Alehouse Recognizances* detail that a William Prime was the licensee. To the side of the inn is Cedar Road with its network of roads such Chelmer Drive and Fairview Avenue, leading eventually to the former council estate around Hutton Drive. In the distance of the top photograph is Wash Road (off to the left) and the land that belonged Collins Farm, which has been built on to form another of Hutton's council estates.

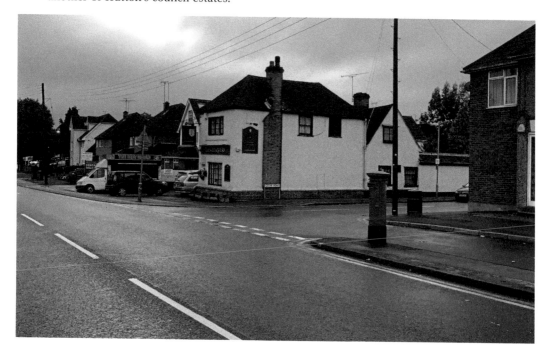

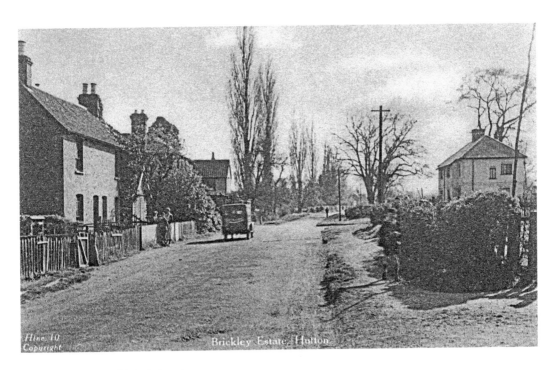

Brickley Estate and Wash Road, c. 1930

The photographer is standing in Wash Road facing towards Rayleigh Road. In the right of the top image (behind the house) is the entrance into the road now called Woodlands Avenue (then Brickley Road). Behind the poplar trees in the centre is Edwards Farm, now the location of Edwards Way. The top photograph must have been taken at the early days of the construction of the large council estate on the farmland, which once belonged to Hutton Poplars.

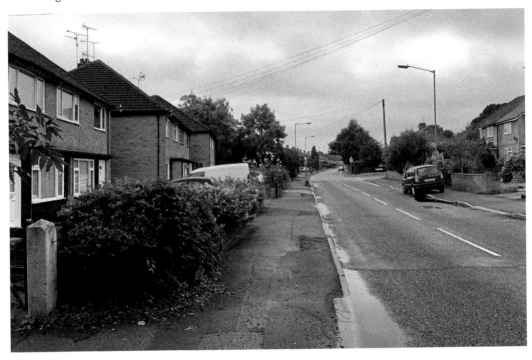

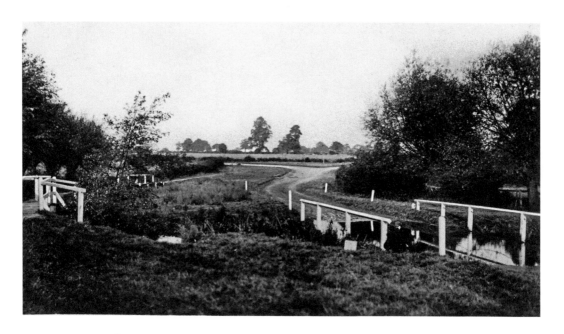

Hutton Wash, c. 1910

At the northern end of Wash Road, after the railway tunnel, the road has a small bridge over the River Wid. Today's bridge was built in the 2010s and is constructed and designed to withstand the rigours of continuous twenty-first-century traffic, along with the challenges of an often flooding river. However, in the past this bridge was not as robust; local newspapers in the 1870s reported that the bridge was very dilapidated. In 1880, they then recounted that the cost of a new bridge was £43 19s 8d. However, this new bridge still did not alleviate the problem of flooding; just two years later, newspapers stated that the road over the river had flooded and was often impassable. The scene above shows a small boy playing in the water from the flooded River Wid and that the problems of flooding on the road had still not been resolved by the time of this 1910s photograph. Hopefully today's modern bridge will prove more successful than its predecessors.

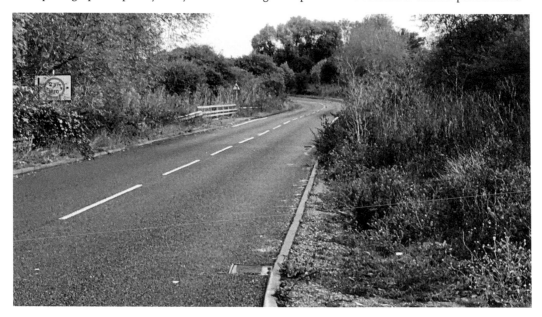

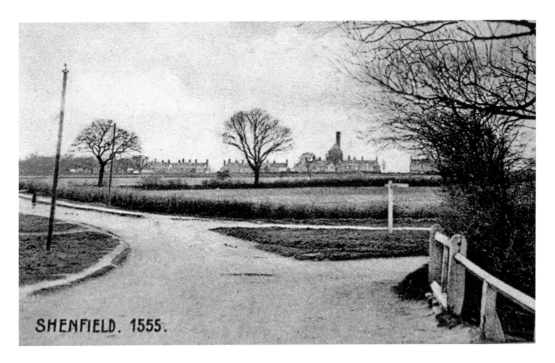

SHENFIELD. 1555.

Hutton High Road and Rayleigh Road (facing towards Shenfield), early 1900s
On the right is the entrance into Wash Road. Ahead are the rural fields and farmland that then belonged to Hutton Poplars School, with the school's boiler room's chimney a distinctive landmark in the distance. Other school buildings are also noticeable in the distance. This scene is almost unrecognisable today, with most of the school's land built on in the 1930s to form one of Hutton's council estates. Later on in the twentieth century, more houses were built on the former school's land to form the luxurious housing development known as Hutton Poplars.

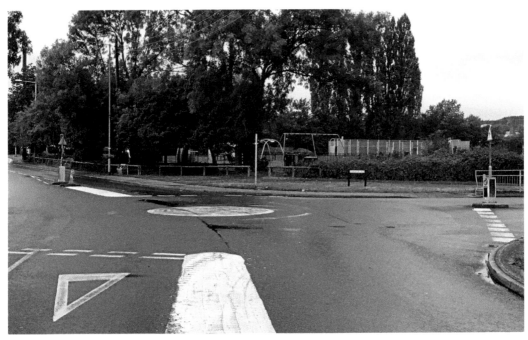

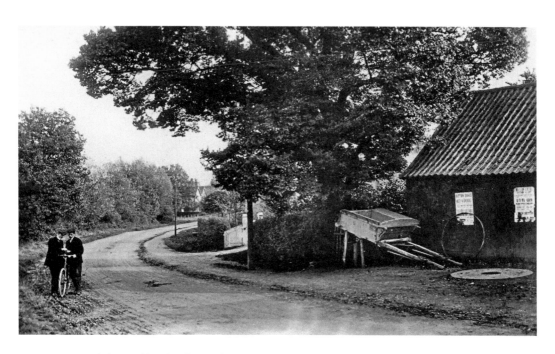

Hutton High Road/Rayleigh Road (facing away from Shenfield), early 1900s

Now renamed Rayleigh Road, the rural street scene of a narrow country lane in the top photograph is very different today. The cyclists are standing in the area that has now become a side road from the main road, Sun Ray Avenue – part of an area of Hutton that became known in the 1930s as the Hutton Garden estate. In the distance are houses that mark the corner of Oakwood Avenue. On the right is Hutton's Victorian blacksmith's forge; on its side is two bill-posters. One is for the sale of Freehold Cottages and Blacksmith's shop by Vaizey and Coverdale at the Lion and Lamb Hotel in Brentwood, the other advertises an Autumn Show. Today the forge has long gone and houses are all along this once sleepy country road.

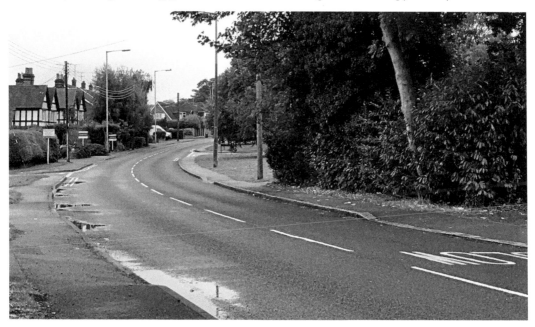

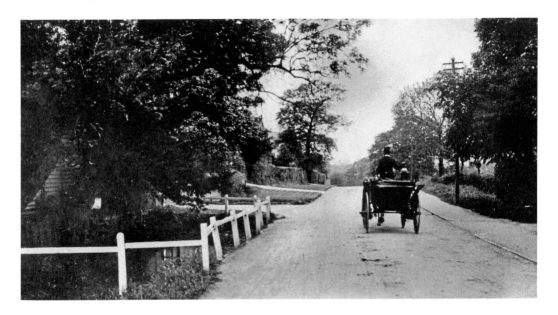

Southend Road/ Rayleigh Road, c. 1910

Over the last century or so, the road from Shenfield through to Billericay via Hutton has had several names. The first part of it, from Shenfield Railway Bridge, was called either London Road (as recorded in the 1901 census) or more commonly Hutton High Road. From approximately Mount Pleasant Avenue onwards to Hutton Village Road, the road's name was sometimes Billericay Road (as per 1901 census) and sometimes Southend Road (as shown in the above postcard). In the 1920s and 1930s Sun Ray Home Limited offered new houses for sale in 'Hutton Garden Estate, Southend Main Road, Hutton'. Today, the entire road from Shenfield to the start of Billericay is called Rayleigh Road. With all the modern day buildings on Rayleigh Road, it is difficult to identify the exact location of the above street scene, but it is likely to have been photographed somewhere between the Wash Road roundabout and Hutton Village road. The bottom photograph is the 1930s built Sunray parade.

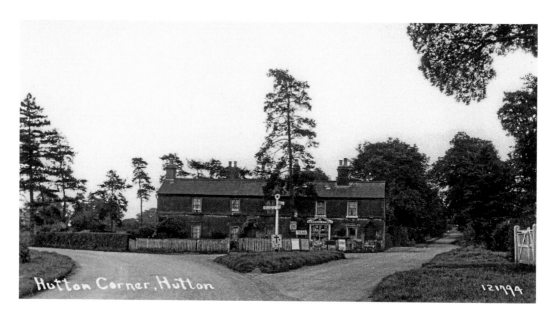

Hutton Corner, Hutton

121194

Hutton Village, *c.* 1920

To the left, the Rayleigh Road continues on through to Billericay. To the right, Hutton Village Road becomes Hall Green Lane before running into Church Lane. The buildings in the centre of the postcard are now all residential houses but for many decades one of the cottages housed a general store and sweet shop. The sign on the shop's second doorway (to the right-end in the top photograph) reveals that the store was called Hutton Corner General Stores. This part of Hutton has a more tragic past. In 1850, a police constable was escorting a prisoner from Billericay to Brentwood by foot, but the prisoner, twenty-year-old William Wood, started a kafuffle during which both men fell into a pond near the junction of Rayleigh Road and Church Lane. Wood tried to drown the policeman by holding him under the water and stuffing mud into his mouth. But then Wood thought better of murdering him and pulled the policeman from the pond. However, the policeman, Robert Bambrough, was mortally injured and died a few days later. In 1990, Billericay Police constructed a memorial stone close to the place where the pond once was to commemorate the policeman's death.

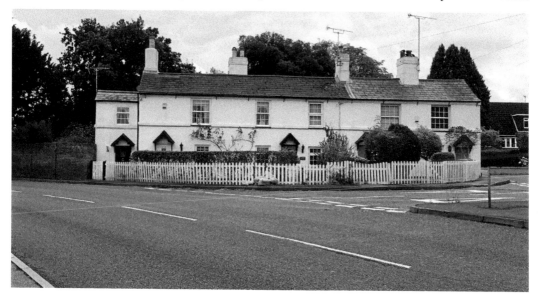

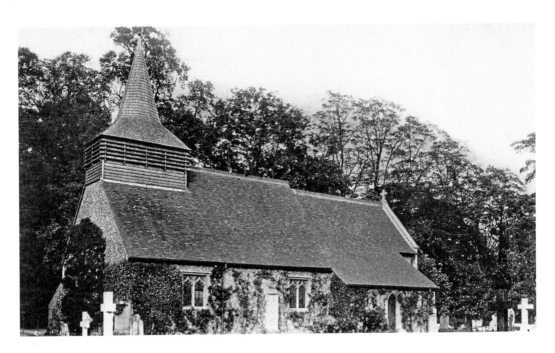

All Saints Church, Church Lane, c. 1910

Parts of All Saints Church date from the first part of the fourteenth century, although it is thought that an earlier church existed on the site long before the 1300s. The church was extensively rebuilt, renovated and repaired during the nineteenth century by the famous Victorian church architect, G. E. Street (d. 1881 and buried in Westminster Abbey). In the 1950s, another church, St Peter's (*see* inset), was built in the centre of modern-day Hutton in Claughton Way, with All Saints Church being its mother church. Today, the two churches are united to offer Hutton's Church of England population two places to worship – one ancient, the other modern.

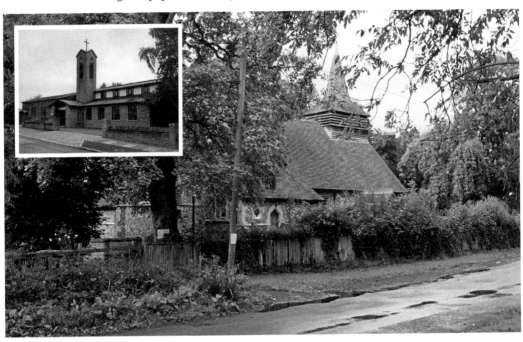

Bibliography

Secondary Sources

Bettley, J. and Pevsner, N., *The Buildings of England, Essex* (Yale University Press, 2007).

Copeland, J. & Harris, N., *The Old Photographs Series: Brentwood* (Alan Sutton Ltd, 1994).

Essex County Council, 'Brentwood Conservation Area Appraisal and Management Plan', 2007.

Essex County Council, 'Great Warley Conservation Area Appraisal and Management Plan', 2009.

Marriage, J. *Bygone Brentwood* (Phillimore & Co., 1990).

Simson, F., *Brentwood in Old Picture Postcards* (European Library, 5th Edition 1989).

Tames, R., *Brentwood Past* (Historical Publications Ltd, 2004).

Ward, J., *Brentwood: A History* (Phillimore, 2002).

White, W., *History, Gazetteer and Directory of the County of Essex* (1848).

Secondary Sources – Websites (all consulted autumn 2016)

Anon, Lost Hospitals of London, 2008-2016, http://ezitis.myzen.co.uk.

Anon, Derelict Places: Documenting Decay, http://www.derelictplaces. co.uk/.

British Library, The British Newspaper Archive, http://www. britishnewspaperarchive.co.uk/.

George, P., History House: Essex A-Z, http://www.historyhouse.co.uk/.

George, P., History House: Shenfield, http://www.historyhouse.co.uk/ placeS/essexs08.html.

Goodge, M., British Listed Buildings, http://www.britishlistedbuildings. co.uk.

Hunter, I. and Wilding, K., Essex Pub History, http://pubshistory.com/ EssexPubs/pubindex.shtml.

Higginbotham, P., The Workhouse, 2016, http://www.workhouses.org.uk/.

Lewis, S., (Edt), 'Shenfield - Shere', in *A Topographical Dictionary of England*, (London, 1848), pp. 69–74. British History Online http:// www.british-history.ac.uk/topographical-dict/england/pp69-74/.

Palmer, J. J. N. and Slater, G., Open Domesday, http://www. domesdaymap.co.uk/.

Powell, W. R. (ed), 'Little Warley', in *A History of the County of Essex: Volume 7*, (London, 1978), http://www.british-history.ac.uk/vch/ essex/vol7/pp174-180.

Powell, W. R. (ed.), 'Great Warley', in *A History of the County of Essex: Volume* 7, (London, 1978), http://www.british-history.ac.uk/vch/essex/vol7/pp. 163–174.

Powell, W. R., Board, B. A., Briggs, N., Fisher, J. L., Harding, V. A., Hasler, J., Knight, N. & Parsons, M. (ed.) 'Parishes: Brentwood', in *A History of the County of Essex: Volume 8*, (London, 1983), http://www.british-history.ac.uk/vch/essex/vol8/pp90-109.

Acknowledgements

Dates attributed to postcards are based on postmarks and/or dates the photographers were active and/or serial numbers on the postcards. Postmarks can only ever be a rough estimate of the date of the postcard – sometimes people purchased postcards but used them many years later, or shops kept old stock for many years. Therefore, postmarks are only ever the last possible date of that postcard's view.

Every attempt has been made to seek permission for copyright material used in this book. However, if we have inadvertently used copyright material without permission or acknowledgement we apologise and we will make the necessary correction at the first opportunity.

I would like to thank the readers of my blog, www.essexvoicespast.com, and my connections on Twitter at @EssexVoicesPast who have encouraged and helped me throughout my time writing this book.

Also Available from Amberley Publishing

A charming collection of postcards from those who served
during the First World War.

Paperback
96 pages
978 1 4456 3500 2

Available to order direct
please call **01453-847-800**
www.amberley-books.com

Also Available from Amberley Publishing

KATE J. COLE

BISHOP'S STORTFORD

THROUGH TIME

The No. 1 Best Selling Colour Local History Series

OVER 400,000 COPIES SOLD

This fascinating selection of photographs traces some of the many ways in which Bishop's Stortford has changed and developed over the last century.

978 1 4456 3493 7

Available to order direct
please call **01453-847-800**
www.amberley-books.com

Also Available from Amberley Publishing

This fascinating selection of photographs traces some of the many ways in which Sudbury, Long Melford and Lavenham have changed and developed over the last century.

978 1 4456 3680 1

Also Available from Amberley Publishing

This fascinating selection of photographs traces some of the many ways in which Billericay & Around has changed and developed over the last century.

978 1 4456 4926 9

Available to order direct
please call **01453-847-800**
www.amberley-books.com